D0933720

Miniatures

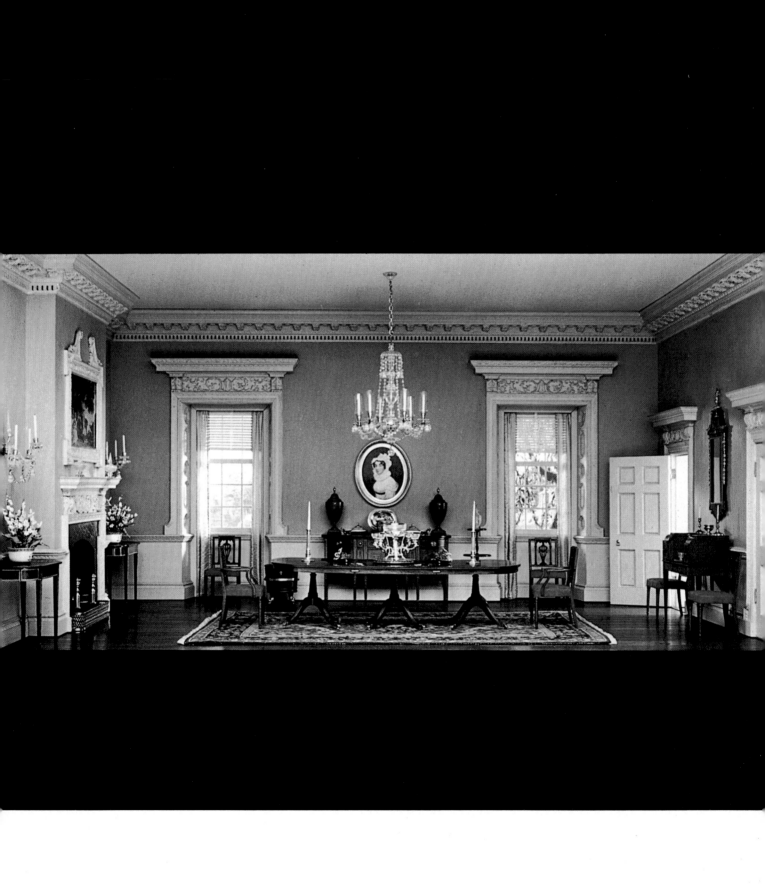

THE SMITHSONIAN ILLUSTRATED LIBRARY OF ANTIQUES

General Editor: Nancy Akre

Miniatures

Compiled for the Cooper-Hewitt Museum

COOPER-HEWITT MUSEUM

The Smithsonian Institution's National Museum of Design

ENDPAPERS

Charms in the collection of the Cooper-Hewitt Museum;
these, like most, bear no marks indicating where, when or
by whom they were made. Probably late nineteenth century.
Gift of Susan Dwight Bliss

FRONTISPIECE

One of the ninety-seven miniature period rooms designed by
Mrs. James Ward Thorne. This elegant Georgian dining
room is modeled after that in the Hammond-Harwood House
built in Annapolis, Maryland, between 1770 and 1774 for
Matthias Hammond, a lawyer and planter. American, 1933–
42. Height: 34.4 cm. (13¾ in.). The Art Institute of Chicago

Art Direction, Design: Joseph B. Del Valle

Contents

1 INTRODUCTION 7

2 MINIATURE HOUSES AND ROOMS 13

3 FURNITURE 45

4 SILVER 65

5 POTTERY, PORCELAIN AND GLASS 81

6 MINIATURE BOOKS 99

7 ADVICE FOR COLLECTORS 117

 Glossary 122

 Reading and Reference 123

 Some Public Collections of Miniatures 124

 Index 125

 Acknowledgments/Credits 128

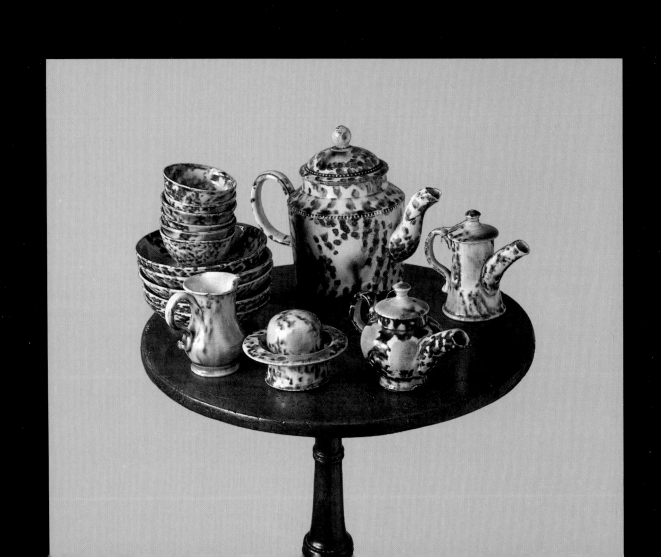

1 Introduction

Anyone who has become fascinated by the world of miniatures can attest that the phenomenal appeal of this tiny universe is anything but simple. It encompasses a world nearly as diverse as the larger world it imitates, and the channels it touches in us run as deep as our dreams.

Imagination is, and always has been, one of the miniaturist's most valuable tools. There is really no limit to what the miniaturist can dream of doing: he can endeavor to take any part of the world and make it small—indeed, it almost seems that he has succeeded. The flora and fauna of the earth, humankind in its myriad guises and virtually the entire man-made environment have all been captured in miniature. These diminutive creations remain as evocations of a time gone by in which we can see the world as it was, or as someone may have dreamed it should be; through such pieces we can share in the reality, or in the dream.

Miniaturization is a process that begins and ends with thinking small. To appreciate such tiny wonders, it is essential to visualize the finished product not as a reduced version of something big, but as something small in its own right and by its own nature, a harmonious whole in which all parts, small though they may be, are in proportion to each other.

Around the third and fourth millennia B.C. in the Near East, the Far East and South America, dolls were being made that were intended as familiar companions for persons who had died and who were striking out into another, yet more fearful world. These dolls were not toys, nor were they made for the sheer enjoyment of rendering in miniature something from the everyday world. They were serious religious objects, to be treated with reverence, and it was from

Colorplate 1.
The distinctive glaze pattern decorating these miniature tablewares indicates that they were made in Staffordshire, England, perhaps at the Whieldon pottery, which produced mottled glaze earthenware that was widely imitated throughout the area. However, since Whieldon, along with many of the other potteries in Staffordshire, failed to mark its miniature wares, attributions to this manufactory can only be tentative. Whieldon-type ware, Staffordshire, England, probably nineteenth century. Height of coffeepot: 5 cm. (2 in.). The New-York Historical Society

such reverential objects that the art of miniaturization began to branch out and develop.

In ancient Egypt, where beliefs in the afterlife were highly developed, tombs were furnished not only with miniature people (notably servants who facilitated the deceased's needs as they had in life), but also with all kinds of diminutive equipment: boats, kitchen utensils, chariots, furniture and so on, in great variety. One pharaoh had 365 small "servants" buried with him; another had almost twice that number. Among the miniature models entombed with Meket-Re, an Egyptian court official in Thebes, were a butcher shop and weaving shop (plates 1 and 2), a garden and five other rooms, complete with occupants going about their daily chores.

It was particularly important that these articles be faithful replicas. They were not solely to be looked at and admired; they were made for service in the literal sense of the word. They would be with the deceased when he reached the divine underworld, and in this place of life after death they would once again be ready for their master's use. Servants, cooking utensils, chariots or other conveyances were all

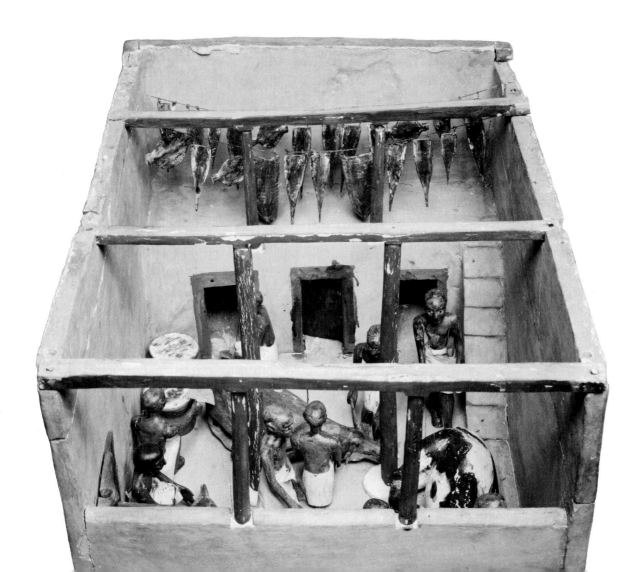

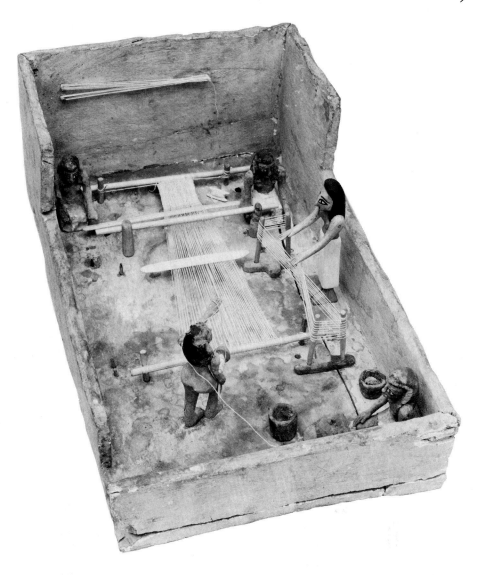

expected to perform at the same level of excellence as the genuine article their user had known in life.

By the sixteenth century, when most of the antique miniatures available to today's collectors began to be made, other aspects of man's consciousness drove him to strive for exacting realism in his miniature creations. Often the impetus was the joy he received in indulging the delightful fantasies of children who saw in every *dollhouse* or toy train the wonderful possibility that by magic these small objects might grow to full size and be "just like real"—or the equally intriguing fancy that the children themselves might shrink to miniature size and be at home in this lovely, tiny world. For young and old alike, there was the wonder of having at their fingertips a world they could control.

1 and 2.
Among the many miniature items buried with Meket-Re, an Egyptian court official in Thebes, were these models of a slaughter-house and a weaving shop. Intended to ensure the deceased's well-being in the after-life, they are realistic models of their real-life counterparts. Egyptian, XI Dynasty (c. 2000 B.C.). Length of slaughterhouse: 76 cm. (30 in.). Length of weaving shop: 59 cm. (23½ in.). Slaughterhouse: Rogers Fund and Edward S. Harkness gift, 1920. Weaving shop: anonymous gift, 1930. The Metropolitan Museum of Art, New York

The idea of finding a certain peace of mind by re-creating the large and unmanageable world in miniature probably underlies much of the satisfaction with which we greet miniatures. Vivien Greene, a noted English dollhouse curator and author, speaks for many collectors and enthusiasts when she describes how her interest in dollhouses and furnishings arose out of the loss and emptiness she felt after her home and possessions were destroyed during the bombing in World War II.

"It was my own house being bombed," Mrs. Greene has written. "It had an incendiary bomb early in the War. This was a very deep shock. I lost a lot of personal things, family things. It took some time to get over this. When I did, I had a terrible feeling of having nothing. I began to think how lovely to have a little house of my own."

The tradition of verisimilitude has been a guiding principle of miniaturists from the beginning, and this has imposed certain imperatives on the makers of true miniatures. First of all, there has always been the inviolable necessity of *scaling down* the measurements of the objects to be copied in miniature. A scale of one inch to a foot has been widely used for at least several centuries for miniature rooms and their furnishings—so widely as to be almost standard. Conversion tables for a variety of scales have been available to the miniaturists, and pre-converted plans have also been used. In these, converted measurements are applied to original plans, as was the case with the Chippendale furniture executed in miniature for the Nostell Priory Dollhouse, built in England in 1740.

In spite of the most sophisticated measurements, however, there has always been one particular bugaboo in the art of miniaturizing, which has probably separated the artists from the artisans since the time of the pharaohs. From the viewpoint of logic it makes no sense, but the possibility has always existed that once all the furniture and accessories were in place, something would not look quite right. The essential harmony of the piece would seem to be missing—perhaps because the legs of a table were too thick, or the top of a desk too heavy or lacking in grace. Generally, it can be taken for granted that in such examples measurements have been faithfully adhered to; and yet the result is not always a perfect harmonious whole.

Over the ages arguments must have arisen as to why this should be so, but in part, at least, the answer surely lies in how the eye handles scale—a sort of optical illusion. A table leg that tapers from one inch square at the top to a half-inch at the bottom becomes, when it is scaled down, unnatural, like a spike heel. Four such legs on a miniature Chippendale table may be more than the eye can take, even if they are micrometer-exact in size (see plate 43). For judg-

ments of this sort, the accuracy of the builder's eye probably exceeds the micrometer in determining when the proportions are right.

It is reasonable to suppose that the techniques of making miniatures developed hand in hand with the methods of making full-sized artifacts. An eighteenth-century model of a dining room table was made in pretty much the same way as the table from which it was copied. Part of the charm of antique miniatures is that they demonstrate so faithfully how these methods have been followed and preserved. In modern products, although the reproduction may be faithful, the methods are all too often those of the modern age. Casting may produce more and cheaper brass lamps, for example; an extrusion press may spew forth plastic table legs by the dozen and decorative paneling by the yard; but any resemblance of the finished products to the careful craftsmanship of earlier times is purely fortuitous.

Modern mass production is one of the reasons that antique miniatures are so much sought after today. In the final analysis, it is not control but freedom that so delights the eye in a really wonderful miniature. Our eyes are tricked—and somehow we let the little image before us defy our knowledge that it is small and a replica. By surprising us, it allows us to escape into its own perfect world.

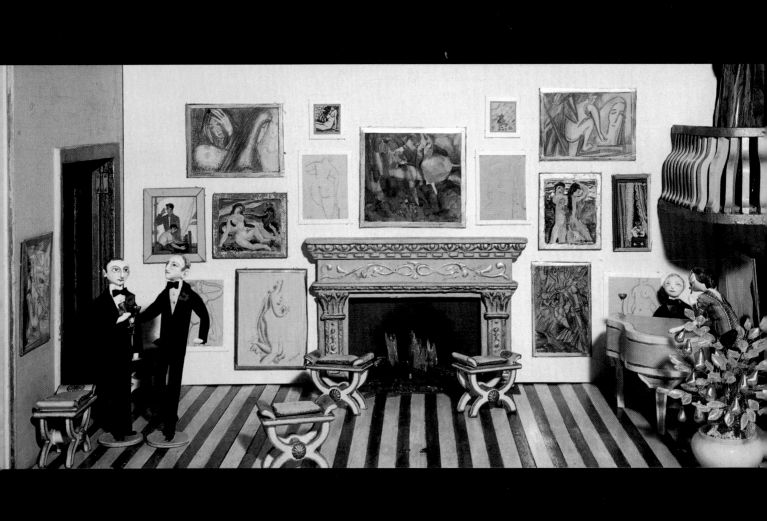

2 Miniature Houses and Rooms

If we pause to think about the whole idea of miniatures, we find ourselves at one time or another confronted with the perhaps uncomfortable thought that miniatures are a kind of toy for adults. The discomfort that this thought can produce, however—at least in those who have not yet surrendered themselves to the complex charms of miniatures—is a comparatively recent one. It is as recent, in fact, as the eighteenth-century notion that childhood is a period distinct from adulthood, and that the child is not a "little man," but a totally different being.

The first full-fledged miniature houses on record were created in Bavaria in the sixteenth century. So extraordinarily realistic were these early houses, such complete models of properly organized, well-run Bavarian homes, that to this day they stand as invaluable documents for the social historian. Usually they were created by carpenters and craftsmen for royalty and well-to-do or middle-class families. The widow Anna Köferlin of Nuremberg, "to whom it had not been granted to be the mother of children," was an exception. Although she was not a woman of means, she determined to own a fine dollhouse, and in 1631 she circulated a broadsheet inviting people to visit the remarkable house she had bought and furnished herself. Beneath a woodcut of the house she printed a bold and rambling poem explaining how children and young girls could benefit from viewing this display of domestic organization:

"But what is therefore placed before your eyes, prepared without complaint over some years for the young, put together with industry and much effort, to provide instruction for the young, that they, too, shall from their young days become accustomed always to be

Colorplate 2.
The lives of the legendary Stettheimer sisters of New York City—Carrie, Ettie and Florine—and their equally famous friends have been immortalized in the house designed by Carrie Stettheimer. Marcel Duchamp and Gaston Lachaise converse in the doorway of the ballroom, while Virgil Thomson plays the piano for Fania Marinoff, wife of Carl Van Vechten. The paintings and drawings in the room were provided by the Stettheimers' talented friends and include works by Marguerite Zorach, Claggett Wilson, Gaston Lachaise, Louis Bouché, Mme Gela Archipenko, Alexander Archipenko, Albert Gleizes, Carl Sprinchorn and Marcel Duchamp. American, New York, c. 1925 (dolls added by John Noble, 1970). Height: 32.2 cm. (12⅞ in.). Museum of the City of New York, gift of Miss Ettie Stettheimer

doing. . . . Therefore, dear children, look you well at everything, how well it is arranged; it shall be a good lesson to you. So when in time to come you have your own home and God willing your own hearth, you will for all your life put things nicely and properly, as they should be in their own households. For as you know fine well, as our dear old ones used to say: Where disorder reigns in the home, there it is soon over; disorder is a poor ornament. So look you then at this Baby House, ye babes, inside and out. Look at it and learn well ahead how you shall live in days to come. See how all is arranged in kitchen, parlor, and chamber, and yet is also well adorned. . . ."

Bearing in mind that this was a time when the scope of most women's lives lay within their homes, when they received virtually no formal education and more than likely could neither read nor write, it seems probable that Anna Köferlin's little house was not the only one of its time to have been used for its didactic potential.

One of the earliest dollhouses on public record—constructed in 1558 for Duke Albrecht V of Bavaria—was such an astonishingly accurate and detailed record of its period that in 1582 the poet August Maier praised its realism in a formal Latin ode.

The duke expressed his appreciation in a different manner: though he had intended the dollhouse as a gift for his daughter, upon seeing it completed, he kept it for his art chamber. The house no longer exists (in all probability it was destroyed in the Munich Palace fire of 1674). But an inventory carried out in 1598 by Johann Baptiste Fickler, the duke's inventorian, and a history of the project by Dr. J. Stockbauer published in 1874 in Vienna provide information on the contents and the particulars of construction, as well as a vivid account of the guilds that would make Bavaria Europe's dollhouse capital in the late sixteenth and seventeenth centuries.

The 1639 Nuremberg Baby House (often called the Stromer House, after the family who owned it from 1862 to 1939), which was built some eighty years after Duke Albrecht's house, has been luckier in its battle with the forces of time. It remains a very sophisticated structure, even alongside today's most painstaking construction (colorplate 3). The house is built to two scales: the ground floor has eight rooms crowded four across and two deep into the space of a single story, while the second and third floors have but three rooms each, in keeping with the architecture of the time.

The ground floor contains a stall for the cows and horses, complete with a bed for the stable boy; a combination taproom and beer cellar; an office, a storeroom and separate quarters for the male and female servants. The nursery is also at ground level. Of the domestic work-

Colorplate 3.
The Nuremberg Baby House (also known as the Stromer House), which is stocked to the rafters with all the accouterments of a bourgeois home, is a remarkable record of domestic life in seventeenth-century Bavaria. Its larders, linen chests and cold cellar come complete with miniature metal-ware, linens and wooden buckets. German, Nuremberg, 1639. Height: 203 cm. (81 in.). Germanisches Nationalmuseum, Nuremberg

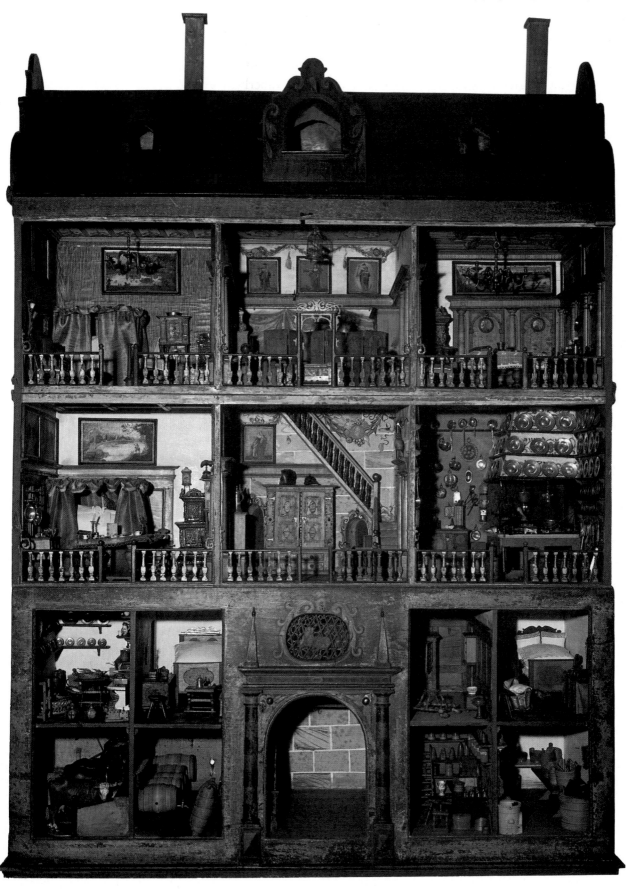

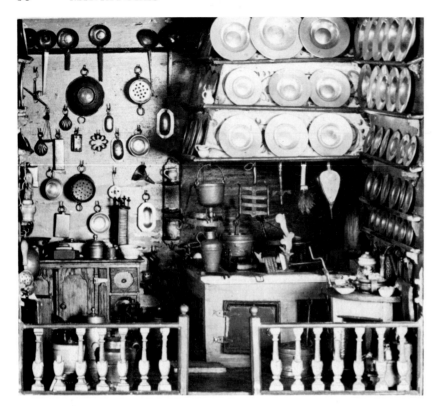

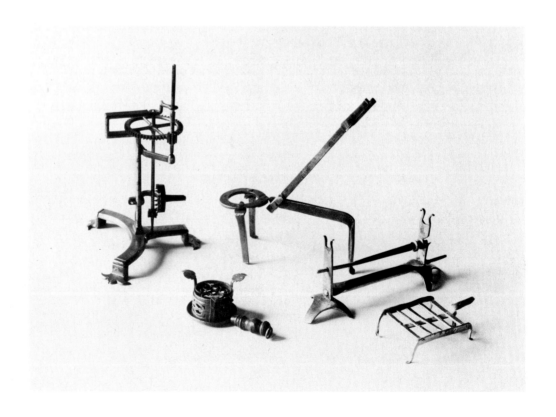

3.
The kitchen of the 1639 Nuremberg Baby House is replete with copper, brass and pewter utensils, as well as other cooking equipment. German, Nuremberg, 1639. Height: 49 cm. (19⅜ in.). Germanisches Nationalmuseum, Nuremberg

4.
The roaster, tripod, turnspit, trivet and chafing dish from the kitchen of the 1639 Nuremberg Baby House.

5.
A lace pillow for making bobbin lace, a yarn winder, reels and a spinning wheel, from a seventeenth-century Nuremberg dolls' cabinet. German, Nuremberg, seventeenth century. Germanisches National-museum, Nuremberg

rooms, only the kitchen is on the second floor, and it is indisputably one of the finest and most documentary of its type and period (plate 3). Jam-packed with hundreds of utensils (plate 4), it is richer than any other miniature kitchen of the time in copper, pewter and brass. The wall on which the prized collection of pewter plates is displayed is painted with a delicate floral design, and the cooking fireplace, which was usually an open hearth in middle-class German homes, is here equipped with doors that are hinged and latched.

The fittings of the Nuremberg Baby House were made with astonishing technical sophistication. The wooden *balustrades* on the second and third floors, for example, are a feature common to sixteenth- and seventeenth-century German dollhouses and reflect a contemporary vogue in full-size architecture. In full-size houses, these balustrades were highly ornate; in the Nuremberg Baby House, however, the balustrading is cut only in outline. All the effects of depth that would have been achieved by carving were simulated with paint. But even close up, it looks as if a master carpenter worked the railings and posts. In the upper hall, a wall hanging featuring draped folds of fabric was done very convincingly with paint instead of cloth; indeed paint was used in a similar way throughout the house to suggest three dimensions.

The accuracy and care with which the miniature furnishings for the

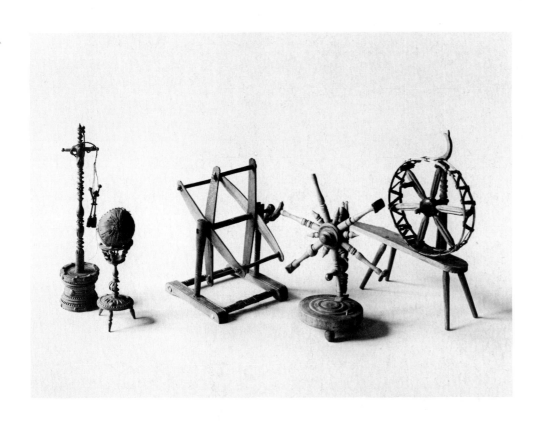

1639 Nuremberg Baby House and other houses from the period were constructed (plate 5) have made them valuable documents in the history of domestic technology, taste and style, and although it was not the intent of their makers, it seems to us that these pieces might have been assembled to tell the story of their lives.

In addition to the miniature houses that were constructed in Bavaria in the seventeenth and eighteenth centuries, miniature rooms of various kinds were designed and filled with all of the objects one would expect to find in their full-size counterparts. Kitchens, in particular, captured the fancy of collectors. They were generally three-sided, roofless rooms, with an assemblage of pots, pans, kettles,

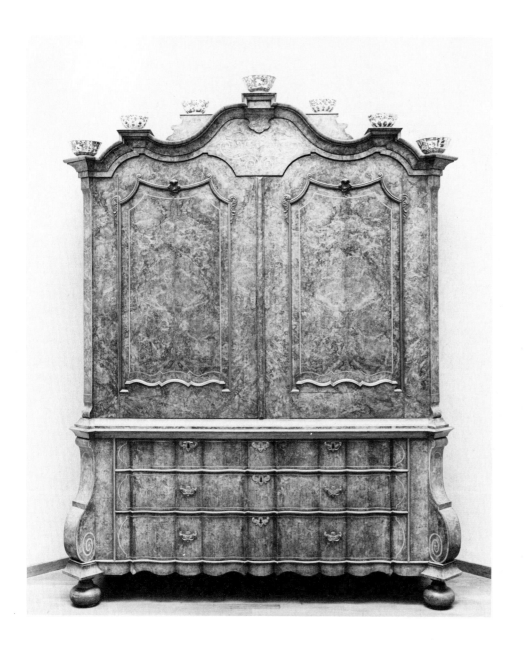

spits, tripods, roasters, a stove and other culinary equipment. The cities of Ulm, Nuremberg and Augsburg all manufactured these miniature kitchens and the furnishings for them, although the type has come to be known as the Nuremberg kitchen.

Some of the most opulent dollhouses ever constructed were built in the Netherlands in the seventeenth and eighteenth centuries. They are called *poppenhuizen* or *Dutch cabinets*, because miniature rooms —often as many as fifteen, all built with painstaking attention to scale—are hidden inside structures resembling fancy china cabinets (plates 6 and 7). The cabinets themselves were meant to be display pieces, as were the miniature pieces of pottery, porcelain, silver (plate

6.
Seventeenth-century Dutch miniature houses, or *poppenhuizen*, were stored in beautifully made cabinets whose shelves were furnished like the stories of a house. The Sara Ploos van Amstel House was probably displayed in its owner's dining room along with other prized possessions. Dutch, Amsterdam, c. 1743. Height: 299 cm. (9 ft. 11½ in.). Gemeentemuseum, The Hague

7.
The Sara Ploos van Amstel House with the doors of the cabinet open.

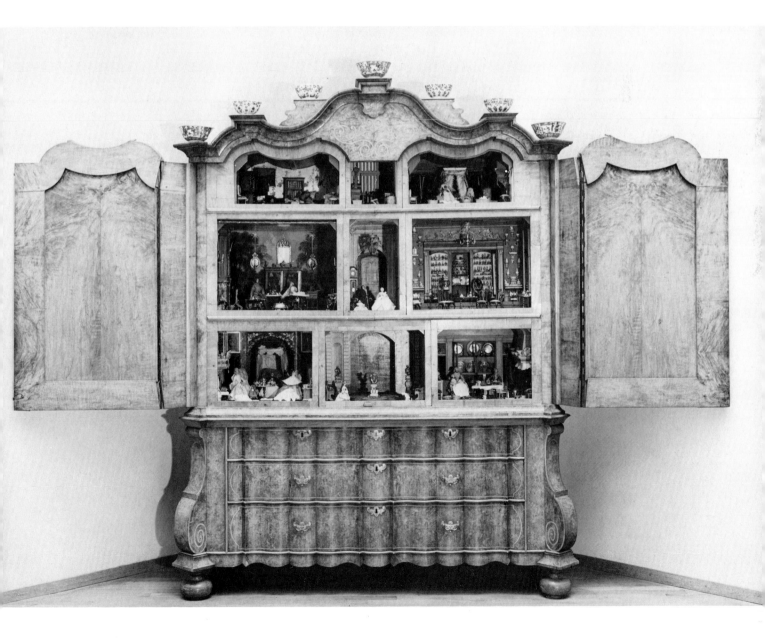

8.
Some of the miniature silver utensils used for cooking in the Sara Ploos van Amstel House. Dutch, Amsterdam, c. 1743. Gemeentemuseum, The Hague

8), furniture and other objects (plate 9) that they held. Whereas the German houses from earlier in the century were carefully stocked and furnished to illustrate the complexity of managing a respectable, well-run house, the Dutch houses were luxury items proclaiming the elegant lifestyle of the wealthy merchant class who owned them.

The best known of these houses is the Petronella de la Court Baby House of 1674 to 1690 (plate 10), which is famous for its furnishings, as well as for the fact that it was the victim of a burglary in 1831. As in a full-scale burglary, the thieves made off with much of the silver, some especially fine pieces of small furniture and a chandelier. Luckily, some of the more precious treasures, such as the music room murals (plate 11), could not be removed, although the thieves seem not to have been art lovers at all, for they also left most of the framed paintings.

Petronella de la Court was the wife of the owner of the Swan

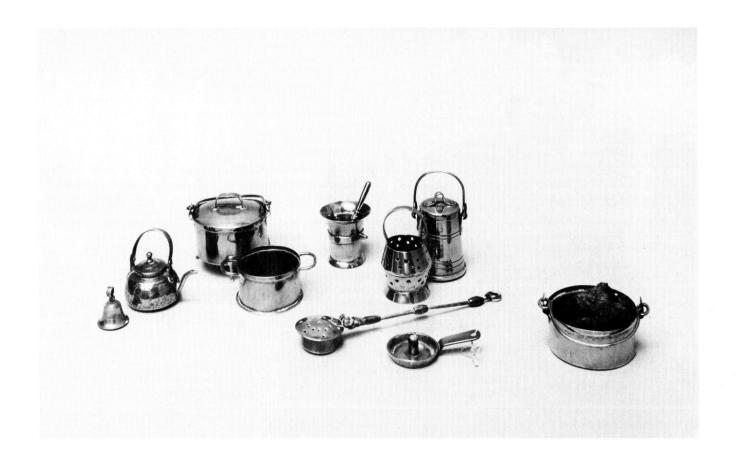

9.
When Sara Ploos van Amstel compiled an inventory of the contents of her remarkable house, she recorded that in the nursery could be found "a high-back chair . . . a night commode, a basket, a workbasket, a basket used to keep baby's clothes, napkins and so on, made of wicker. . . ." Dutch, Amsterdam, c. 1743. Height of chair: 2.7 cm. (1⅛ in.). Gemeentemuseum, The Hague

Brewery in Amsterdam, and her daughter, Petronella Oortman, who had a fine *baby house* of her own (plate 12), was the wife of a dyer. In March 1711, a German traveler, Zacharias Konrad von Uffenbach, reported seeing Petronella de la Court's baby house displayed in her daughter's home amidst a magnificent array of other valued possessions that included paintings, precious stones, carved Oriental agate and porphyry, carved mother-of-pearl, coral, ivory, amber and medals. At the conclusion of his tour, Mr. von Uffenbach writes, Petronella Oortman "asserted, and one may well believe it, that [all] her curiosities cost her more than a hundred thousand guilders."

Looking at the dollhouses of the seventeenth and early eighteenth centuries, one would assume that an apex had been reached in their development and that the future of miniature houses would simply chronicle changing lifestyles and vogues in interior decoration. But dollhouses and their contents have always been more than a mere

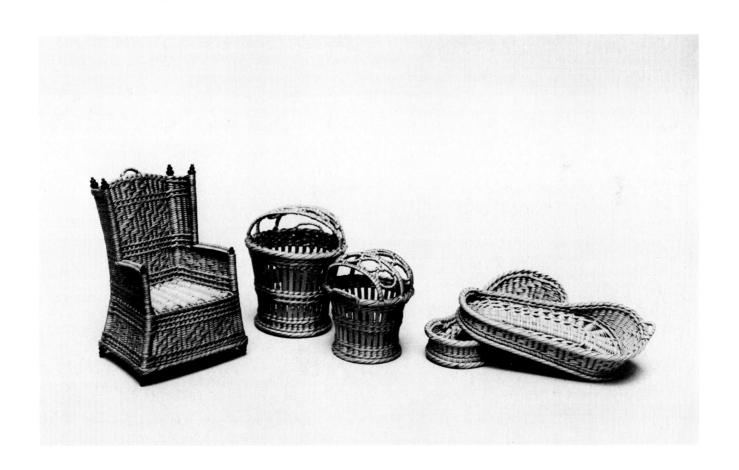

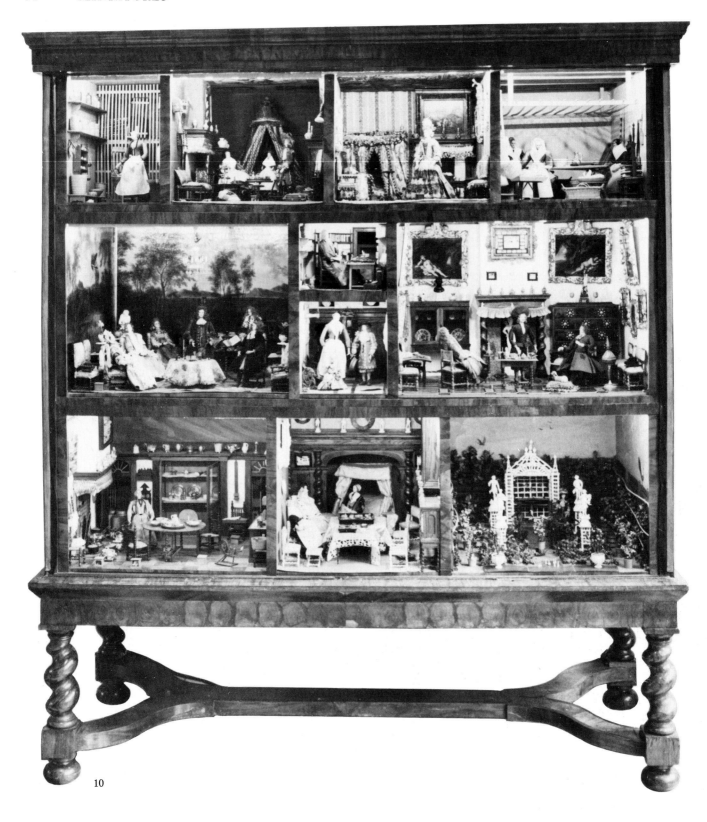

10

10.
The Petronella de la Court Baby House is undoubtedly one of the finest ever made. It is handsomely accommodated in a highly polished cabinet whose style and quality would have complemented the other furniture in the room where it was displayed. The paintings, porcelain, silver and furniture are a reflection in miniature of the opulent furnishings and decor of the homes of wealthy Dutch burghers of the time. Dutch, Utrecht, c. 1674–90. Height: 206.5 cm. (82⅛ in.). Centraalmuseum, Utrecht

11.
The walls and ceiling of the music room of Petronella de la Court's Baby House were opulently painted with murals by Frederick de Moucheron (1633–86). Height: 46.5 cm. (18⅝ in.).

reflection of the decorating styles of their day. Social attitudes, prevailing philosophies about childhood and education, economic factors —all find expression in the manufacture of these little domiciles. As the eighteenth century progressed, and as industrialization brought about sweeping changes at every level of society, dollhouses and their functions changed, too. In keeping with new ideas about childhood, miniature houses were usually designed as playthings for the young. The don't-touch-me look of the earlier houses disappeared, and the little dollhouse owner was invited to move dolls about in the rooms, to rearrange the furniture, to fantasize and to pretend. If the kitchen lacked towels or baskets or cupboards for the sugar and flour, it didn't matter; the child could "make believe." (Interestingly, it seems to be the completeness of the earlier houses that captures the adult's imagination, and the lack of completeness that stimulates the child's.)

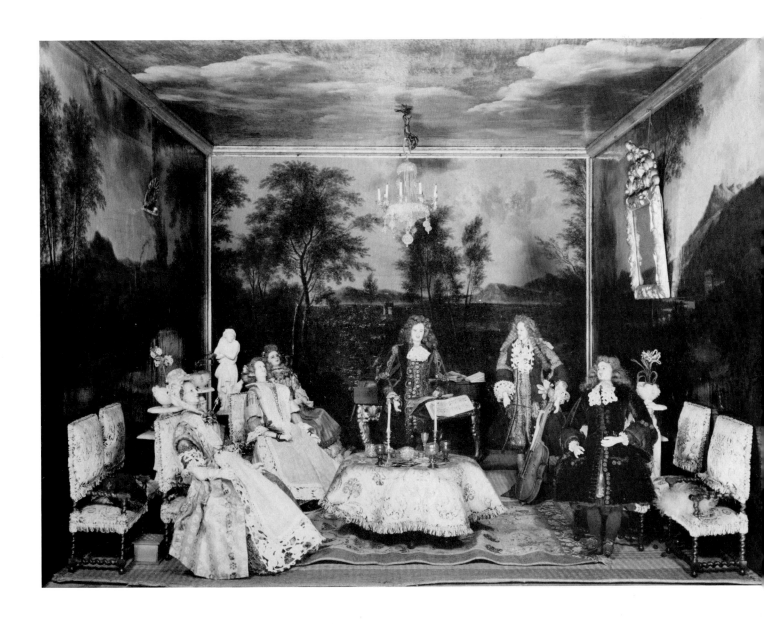

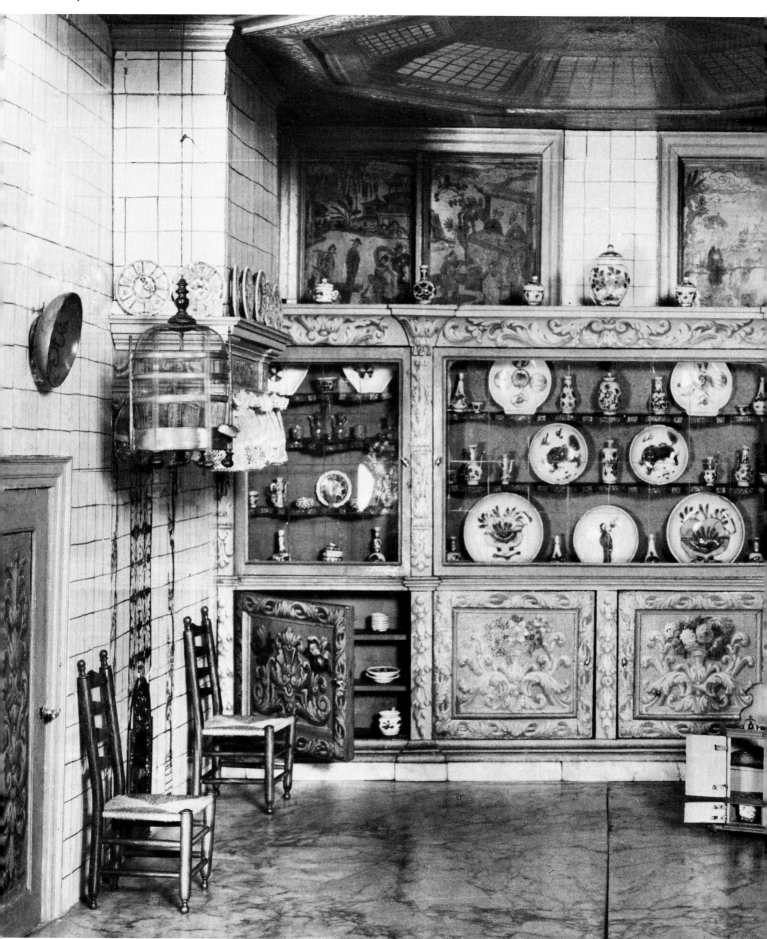

12.
The Dutch housewife proudly exhibited her most beautiful dishes and utensils in her "company" kitchen, which was a separate room from the cooking kitchen. Forming a display-within-a-display, everything shines and sparkles in the company kitchen of the Petronella Oortman Baby House. Dutch, Amsterdam, end of seventeenth century. Height: 76.6 cm. (30⅛ in.). Rijksmuseum, Amsterdam

English baby houses of the late seventeenth and early eighteenth centuries were the direct descendants of the opulent Dutch cabinet houses. One of the earliest English houses on record is that given to Ann Sharp, daughter of the archbishop of York, by her godmother, Queen Anne, sometime after 1691. This fine town house, boasting nine rooms, is installed in a case with cupboard doors. Over the years the house has been treated with such remarkable care and respect that it remains to this day in the possession of Ann Sharp's descendants, with the furnishings and dolls exactly where Ann Sharp left them. Even the names of the little inhabitants are known to us—"Roger, ye butler"; "Fanny Long, ye chambermaid"; "My lord Rochett"—family members, servants and guests are all identified on slips of paper pinned to their clothes or placed on the floor next to them.

Another early English baby house that has been successfully traced to its first owner (a feat that is not often easy since these "domiciles" are usually passed down through the female line of the family) is that built in 1705 by tradesmen on the Isle of Dogs for a young girl, Elizabeth Westbrook. The rooms of the house are installed in an oak cabinet on a tall stand, in the Dutch style, but the top of the cabinet is constructed in the shape of a peaked roof, with the wood carved to represent tiles. A chimney sits atop the house (although one noted dollhouse historian has suggested that it is a later addition), and five windows and a front entryway have been constructed in the doors of the cabinet. Thus the home both displays its Dutch ancestry and is a harbinger of developments to come.

Although the interiors of the miniature houses became somewhat simplified in the eighteenth century, the exteriors did not. By 1730, it had become common to install the little rooms in structures faithfully reflecting popular architectural styles of the day. One of the grandest dollhouses in existence is the Nostell Priory house, built in 1740 in Yorkshire (plates 13 and 14). The architect of the large house at Nostell Priory, James Paine, is thought to have designed the dollhouse; an estate carpenter at Nostell Priory built it; Lady Winn and her sister, Miss Henshaw, provided the nine rooms with such elegant furnishings as yellow silk wall coverings and contemporary flowered chintzes; and Thomas Chippendale (1718?–1779) is reported to have made the furniture. Nor is the exterior outshone by all this splendor: the wood of the facade is convincingly carved and painted to represent the stone of the large house at Nostell Priory; sculpture enlivens the balustraded parapet; fifty-two paned windows and a fan window over the door provide light for the interior; and all the doors have working locks and handles!

As far as is known, the date of the earliest American dollhouse is

13 and 14.
The dollhouse designed by James Paine for Lady Winn at Nostell Priory in Yorkshire, England, is remarkably grand both inside and out (as shown). The exterior of the house was carved and painted by the estate carpenter to resemble the Portland stone of the large house at Nostell Priory, although the sculpture along the parapet is an elegant touch not found on the larger counterpart. English, Nostell Priory, 1740. Height: 165 cm. (5 ft. 6 in.). Lord St. Oswald, M. C., Nostell Priory

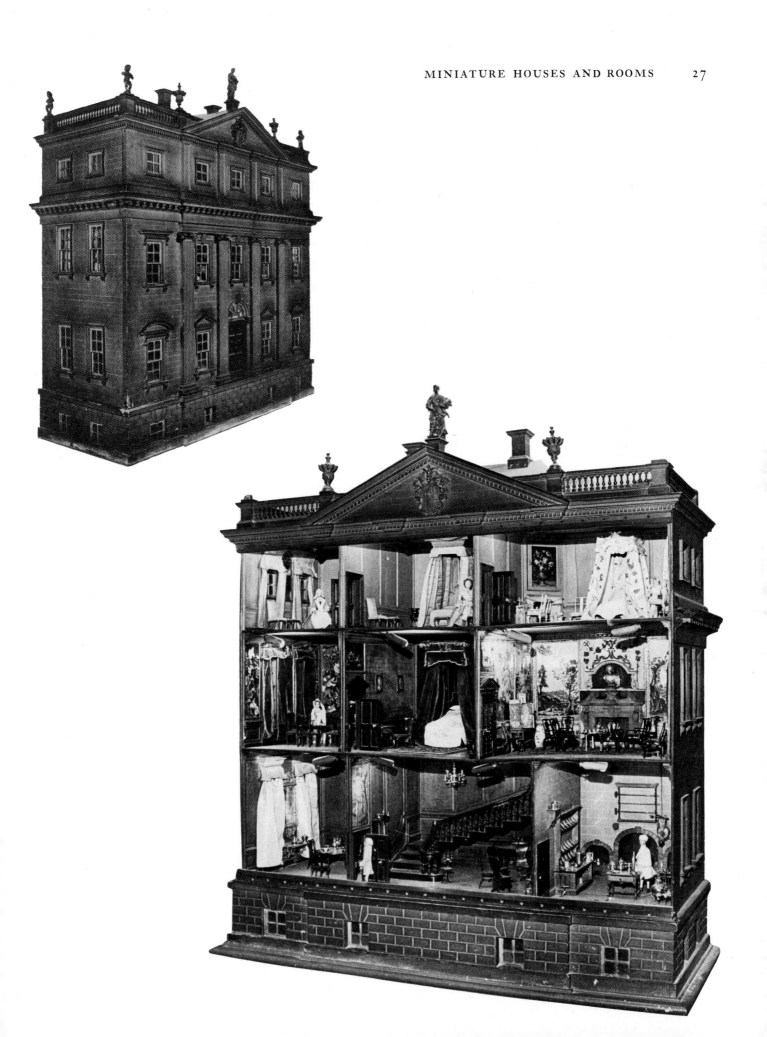

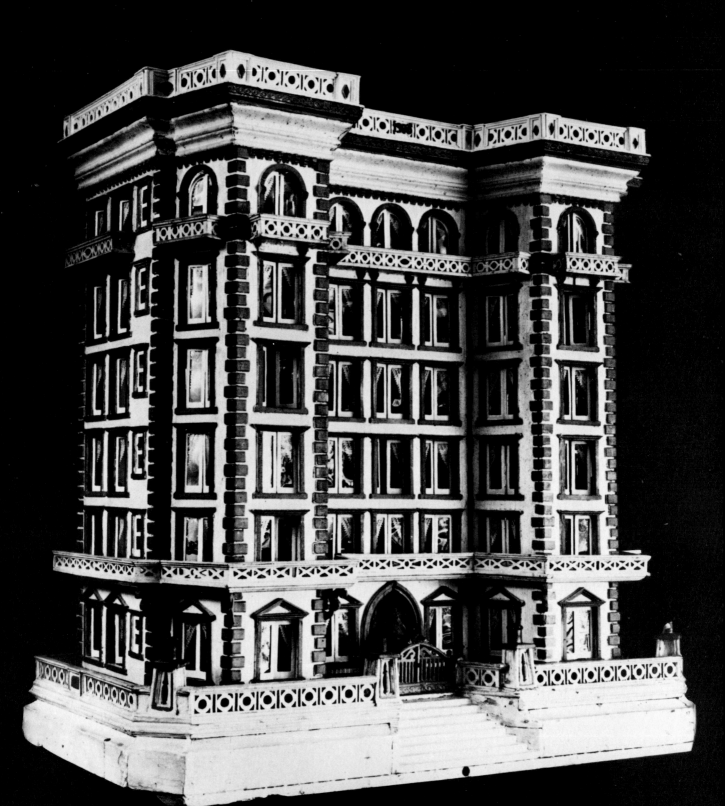

15

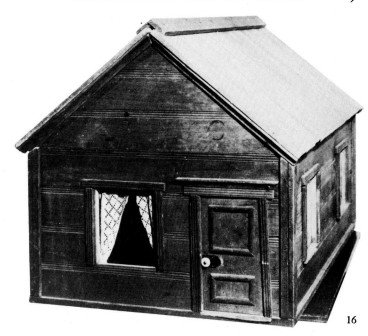

16

1744. Made for a Boston family by the name of Homans, the house is now in the Van Cortlandt Mansion and Museum on the outskirts of New York City. It is open both front and back, a rare feature for dollhouses, and has twice as many rooms as one would expect. The rooms that are back to back are separated not by solid walls but by palings, which admit light. The house also has carrying handles on either side, a gambrel roof, a chimney and a storage drawer below the rooms in front.

The Brett House, completed in 1840, is a most extraordinary dollhouse. The Reverend Dr. Philip Milledoler Brett built this house on South Street in New York City, in the Sail Room of his family's shipping firm. The architecturally ambitious house has a brick fence, iron front gate and a tripartite rather than boxy general shape. The windows are not the customary simple rectangles; many are fan-shaped or have functioning shutters. On the far side of a latticed porch is a garden with a three-hole outhouse.

The interest in accurately representing the exterior of a miniature house continued unabated in the nineteenth and twentieth centuries. In the United States this led to the construction of dollhouses displaying the myriad regional variations in American architecture, from sea-side hotels (plate 15) to simple Maine cottages (plate 16), and from Amish farmhouses to New York brownstones. For the most part, these houses were intended to be children's toys rather than adult amusements, and this is reflected in their appointments; nevertheless, they are usually furnished in keeping with the style of the structure itself, and any idiosyncrasies only lend them an irresistible charm.

15.
There is a realism about this miniature building that suggests it has a real-life counter-part. For a long time it was supposed that a hotel in Asbury Park, New Jersey, was the inspiration, a theory that seems less likely after repeated attempts to locate the hotel have failed. American, 1903. Height: 82.5 cm. (33 in.). The Washington Dolls' House and Toy Museum, Washington, D.C.

16.
Little is known about the maker of this charming Maine cottage except that his name was Harry Smith and he made the house for his two daughters. The exterior, which has never been painted or stained, is of pine, and the cottage has five glass windows and a roof that can be removed to observe the two large wallpapered rooms inside. American, Maine, 1879. Height: 63.75 cm. (25½ in.). Formerly in the collection of Mrs. Delanne Lopeman Dubois, Texas; current whereabouts unknown

Although the owner's own home or another attractive home in the vicinity usually served as a model for these miniatures, inspiration was also supplied by literature and art (plates 17 and 18). And not infrequently the houses were simply "dream houses," representing everything the owner would want in a full-size house—*if* he or she could have it (plate 19).

The collector interested in acquiring antique dollhouses and their furnishings will discover that, although dollhouses from the seventeenth century are extremely rare, examples from the eighteenth, nineteenth and early twentieth centuries are still to be found. Two women, Flora Gill Jacobs in the United States and Vivien Greene in England, have traveled thousands of miles to examine and catalogue the dollhouses and miniature rooms that have been handed down to us over the last three hundred years. To page through the results of

17.
October Afternoon, a print from the N. Currier large folio, *American Country Life*. American, 1855. Museum of the City of New York

18.
This miniature country house is thrice removed from reality. Percy Band, its Canadian builder, received his inspiration from the house in the Currier & Ives print *October Afternoon*. Fanny Palmer, the Currier & Ives artist responsible for the print, drew the house "from life," although the exact identity of her inspiration remains unknown. Canadian, twentieth century. Height: 95 cm. (38 in.). Black Creek Pioneer Village, Toronto

19.
This highly ornate house was built by Leonard Roth of Philadelphia, perhaps as an architect's model. Great care has been lavished on such exterior details as the Orientalized belvedere, the wrought-iron trim around the mansard roof and the carpenter's Gothic trim around the porch roof. An inside staircase and working sash windows are details that one wouldn't normally expect to find in an architect's model. American, Philadelphia, 1876. Height: 150 cm. (60 in.). Smithsonian Institution, Washington, D.C.

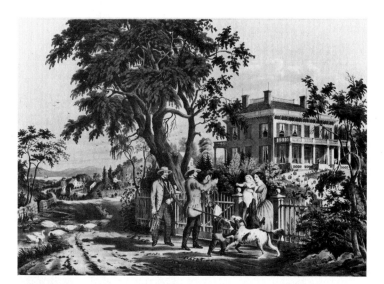

17

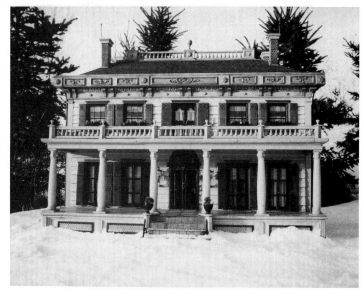

18

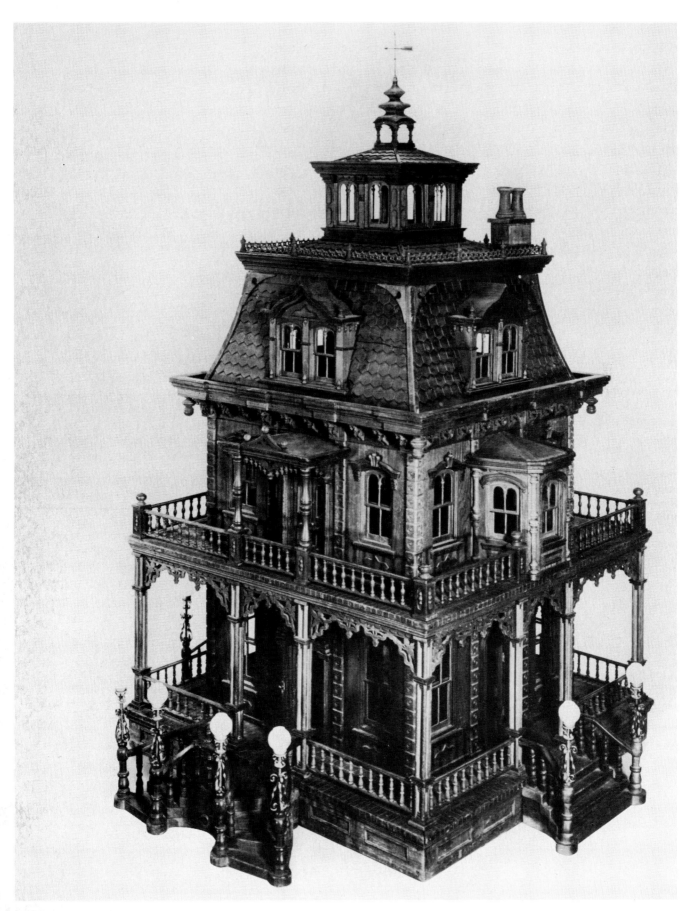

their pioneer work is to begin to understand the wealth of material these Lilliputian creations have to offer the collector and historian.

The twentieth century brings us to several incontestable wonders of the miniature world. Although not in themselves collectible, they are useful to collectors because they have met, or indeed set, the most exigent standards. Queen Mary's Dollhouse at Windsor Castle, which was presented to the Queen by her grateful subjects in 1924, is the pinnacle of realistic dollhouse construction (colorplate 4). Sir Edwin Lutyens, the architect who planned the city of New Delhi, was charged with the assignment of designing the house, on which he and a thousand artists and artisans were to labor together.

The meticulous, indeed astounding, realism of this house inspires enduring awe in most viewers. Several curious responses to its mimetic success are on record. On April 14, 1924, the *New York Times* ran a front-page box with the headline: "Drys Protest Wine Cellars in Queen Mary's Dollhouse." The article recounted that many were "aroused to indignation" by the fact that there were miniature cases of champagne, wine (including an 1820 Madeira) and whiskey that "no self-respecting doll would drink or even have in the house"!

Queen Mary's Dollhouse has functional door locks, an elevator, electric lighting, hot and cold running water, plumbing, an electric iron that grows hot and a vacuum cleaner that works when plugged into a wall socket. The house is contained in a glass case, and without the casement measures one hundred and sixteen inches long. The base is divided into two tiers, with one hundred and four interchangeable cedar drawers on each level. The ingeniousness of these drawers is

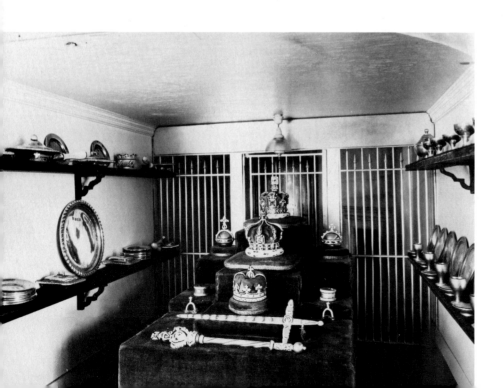

Colorplate 4.
The library in the fabulous dollhouse Sir Edwin Lutyens designed for Queen Mary contains 250 miniature bound books, many of them original works written by prominent British authors of the day. Over 700 miniature prints, drawings and watercolors by British artists are hidden away in the drawers of the cabinets. English, 1924. Height: 38.1 cm. (15¼ in.). State Apartments, Windsor Castle, Berkshire

20.
In safe storage in the strongroom of Queen Mary's Dollhouse lie three crowns, a scepter and mace, two orbs and royal plate. Height: 18.4 cm. (7⅜ in.)

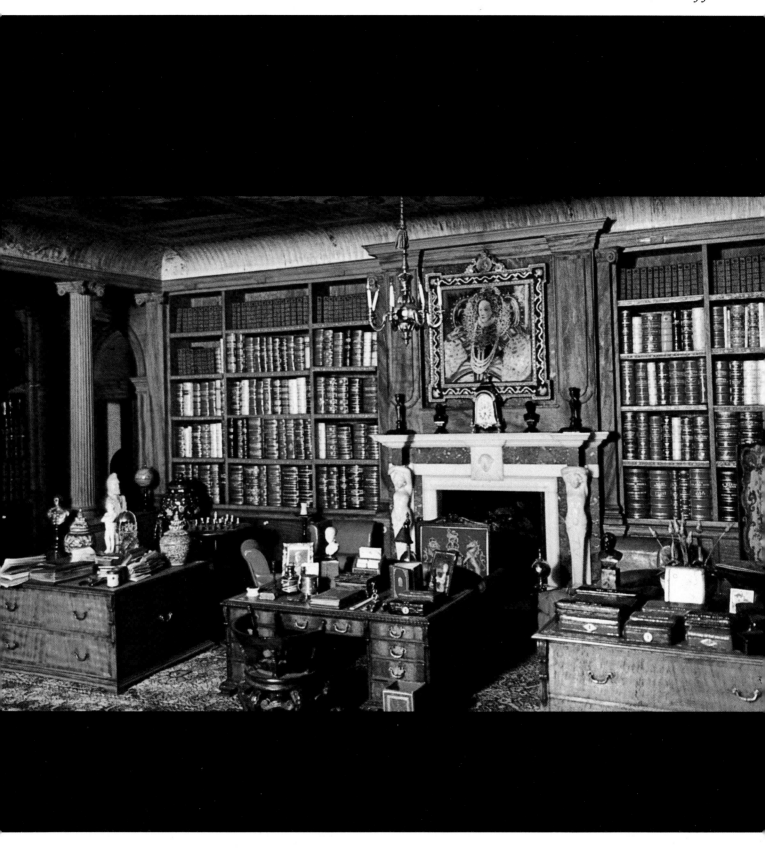

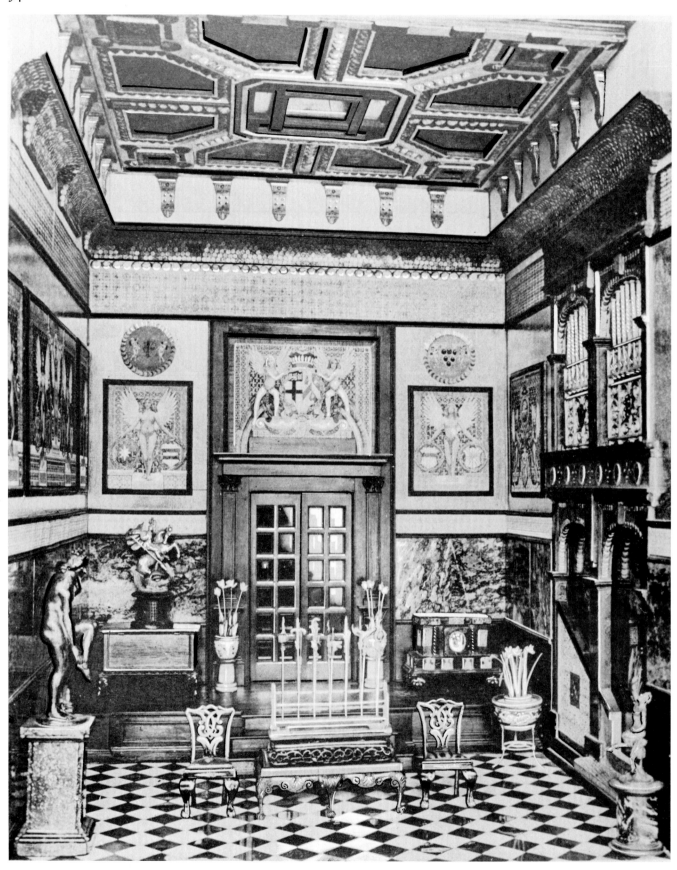

perhaps best illustrated by the one containing the garden designed by Gertrude Jekyll, a landscape architect with whom Lutyens collaborated on many real houses and gardens. Not only does the drawer house snails and a thrush's nest with eggs; when it is closed, the trees, gate and balustrade lie down on the grass amid the flowers, then when the drawer is opened, the trees and flowers literally come up, to mechanically "bloom."

The garage, which also fits into a drawer, features a fleet of 1924 limousines, a Rolls-Royce and two Daimlers and a motorcycle with sidecar. The queen's bathroom, with its mother-of-pearl floor, painted ceiling and alabaster-and-silver tub and sink, is one of the most luxurious rooms in the house. As befits a royal home, there is a strongroom in which are kept crowns, an inlaid scepter, jewels and other treasures (plate 20). The music room is also an extraordinary record of the time, containing more than fifty scores of music by contemporary British composers. These scores are bound in leather with the queen's monogram: each is slightly over one inch square.

The library (see colorplate 4) is unrivaled. Two hundred of England's most celebrated authors were commissioned to do books in their own hand, for what, needless to say, was one of the most limited of limited editions. Miniature prints and drawings are stored in the drawers of the cabinets.

Queen Mary's Dollhouse was completed within four years. Twenty years before the project was begun, Sir Nevile Wilkinson, a soldier and an artist, had started work on Titania's Palace, a dollhouse as fantastic (plate 21) as Queen Mary's is realistic. When Wilkinson learned of Lutyens's commission, he accelerated his pace, determined not to be overshadowed by, as he put it, "all the king's men." He need not have worried, for Queen Mary herself "opened" Titania's Palace on July 6, 1922.

Wilkinson has written that he built the palace in homage to Her Iridescence Titania, an inspiration that came to him while sketching his young daughter in an Irish wood. When the child told him she saw a fairy disappear into the roots of a nearby tree, Sir Nevile vowed to reproduce the Fairy Queen's underground castle. His mythology— a melange of Greek and Roman myths, Arthurian legend, English literature and Wilkinsonian whimsy—is as varied as the palace's architecture. Maintaining that there are "no styles or periods which must be slavishly copied in fairy architecture," Wilkinson simply used what he felt represented the best in the history of building and interior design. The pillars on the four corner towers are Doric, Ionic and Corinthian; the state apartments are decorated primarily in the Italian

21.
The Hall of the Guilds, one of the rooms in the extravagant fairy house known as Titania's Palace built by Sir Nevile Wilkinson for his daughter. English, 1922. Height: 65 cm. (26 in.). Legoland, Copenhagen

manner, with French and German touches; and the chapel contains a group of seventeenth-century French bronzes, a boxwood Holy Family from southern Germany and a copy of a tenth-century Irish Cross of Cong.

Sir Nevile never lost sight of the fact that his house was intended for fairy habitation. All the bedrooms have cupboards for Sunday dress-up wings, and all the doors are *sans* handles and doorknobs, wood being no obstruction to fairies. But the palace is as rich in contradiction as it is in eclecticism. Though fairies don't eat, Sir Nevile provided them with toothbrushes; though they neither walk nor climb, he provided them with glorious staircases.

Titania's Palace, which comprises an area of sixty-three square feet, is built around an Italian garden called the Fountain Court, complete with splashing fountains. There are fifteen rooms. The morning room has what is considered the finest collection of miniature lacquer furniture. In the dining room is a tiny 1650 landscape by Jan Miense Molenaer; Wilkinson conceded that this piece was plundered from another dollhouse but would say no more. One of the oldest objects in the house, dated at 1580, is a gilt bronze and iron cannon on studded iron wheels. Throughout the house there are friezes, paintings and murals.

But the private chambers best reflect the benevolent, even sentimental rulers of this fairy kingdom. In Oberon's study, in addition to his cello and chessmen, is a tiny piece of the late Princess Mary's wedding cake in an ivory casket. In Titania's boudoir, along with her piano and inlaid Louis XV writing desk with a secret drawer, lies the Crystal Tear. Sir Nevile explained: "When babies cry because somebody hurts them or because they are hungry and neglected, the first teardrop always disappears: you can never find it, because it goes straight to . . . Titania's boudoir."

Sir Nevile Wilkinson's dollhouse is a gauge of what can be done in the service of a personal mythology. Colleen Moore's Fairy Castle is a dream of truly fantastic proportions. There are huge differences between Miss Moore's creation and the work of most miniature craftsmen, and yet there are touching similarities, too. Miss Moore's dream palace was built in Hollywood in 1935, and as a movie star every artifice used in making motion picture extravaganzas was available to her. She had a weeping willow that wept real tears into a garden pool. She had a chandelier—made of diamonds and emeralds from her own personal collection of jewelry—put together by a Beverly Hills jeweler. Rockaby Baby sways in a treetop, its cradle

Colorplate 5.
Miss Colleen Moore's Fairy Castle is a tribute in miniature to myths and fairy tales all of us know. Although there is a definitely Disney-like quality to the chapel, this room is more realistic than others in her fantasy construction. American, 1935. Height: 87.5 cm. (35 in.). Museum of Science and Industry, Chicago

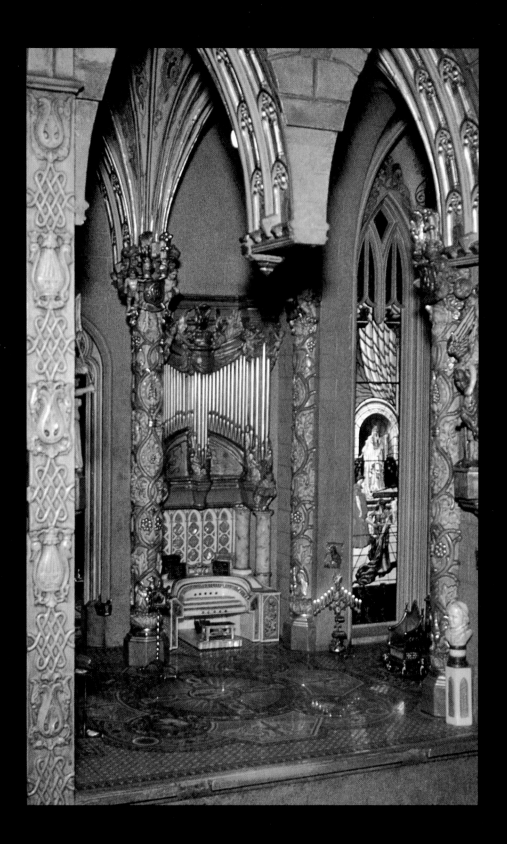

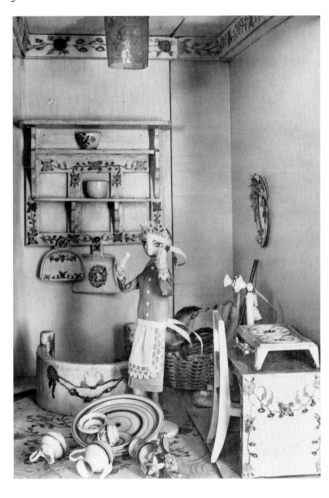

22.
In an upstairs workroom of the miniature house designed by Carrie Stettheimer, the maid has been humorously caught for all time in the act of dropping her employer's dishes. American, New York, c. 1925. Height: 26.3 cm. (10½ in.). Museum of the City of New York, gift of Miss Ettie Stettheimer

rocked by a tiny electric motor. And the whole, of course, is the reflection of an American dream—the American extravaganza as it flourished in Hollywood in the 1920s and 1930s—and will probably never exist again (colorplate 5).

Other ladies with time and money to spare tried their hand at designing and decorating miniature houses and rooms during the twenties and thirties; their efforts were, if not the equal of Miss Moore's in grandiosity, certainly on a par with hers in charm. Carrie Stettheimer, one of the vivacious and sophisticated Stettheimer sisters, managed to express the family wit and style in the house she designed (see colorplate 2 and plate 22). Helena Rubinstein, one of the first women to develop a cosmetics empire, amassed an exceptional collection of antique miniatures—20,000 pieces over fifty years—which two architects and a staff of artists arranged for her in seventeen small glass prosceniums which were dramatically lit and set along dark walls in a specially designed gallery in her Park Avenue apartment. These rooms, which were given such names as "The Old Curiosity Shop"

(plate 23), "A Montmartre Studio" (plate 24) and "Room Romantique," are thoroughly eclectic but genuinely antique in their appointments.

In stark contrast to such flights of fancy, the scale rooms of Mrs. James Ward Thorne represent an unparalleled inspiration to miniaturists concerned with exact reproduction of antiques. Using a scale of one inch to the foot, she constructed ninety-seven miniature rooms as studies in the history of decorative arts. They are cased in glass and placed on dark backgrounds at adult eye level.

Mrs. Thorne's first group of rooms was presented at Chicago's Century of Progress in 1933–34. These thirty-one rooms constitute her most eclectic group of interiors, consisting of American, European and Asian decors. A long-time collector of antique miniatures and dollhouse furnishings, Mrs. Thorne nearly depleted her own cache with this project. She traveled worldwide for furnishings and fittings; when she lacked a necessary item, she commissioned a scale replica of an authentic piece. The Chinese Guest Room is an extraordinary example from this initial wave of rooms (colorplate 7). The furniture and woodwork are of carved teakwood; translucent panels give a particularly airy effect to what is not just one room, but a series of six adjoining compartments. Even the smallest gestures of Chinese hospitality have their correct corresponding appointments: rigid chairs to discourage ungraceful posture; just enough chairs to accommodate the host and his guests, as an overabundance would appear ostentatious; scrolls bearing quotations from literary classics; and an altar in homage to the spirits of departed ancestors.

Her second group of rooms was first shown in 1937 at the Art Institute of Chicago. These documented English and French design from 1500 to 1925, as well as two German rooms, one *Biedermeier*, one *rococo*.

The first room in this series is the Tudor Great Hall (colorplate 6). Its furnishings are reproductions of museum pieces that reflect the English penchant for the Italian Renaissance. The armor is of the kind worn by soldiers of Henry VIII. The portraits are copies: the original of Mary, Queen of Scots, was by an unknown artist; the original of the Duchess of Milan was by Holbein. The rugs here were created by the Needlework and Textile Guild of the Art Institute of Chicago.

The third group of Thorne Rooms consists of thirty-seven interiors presented to the Art Institute in 1942. Twenty-three of these are reproductions of actual rooms in historic houses; fourteen are composite scenes. Represented among the historic houses are Mount

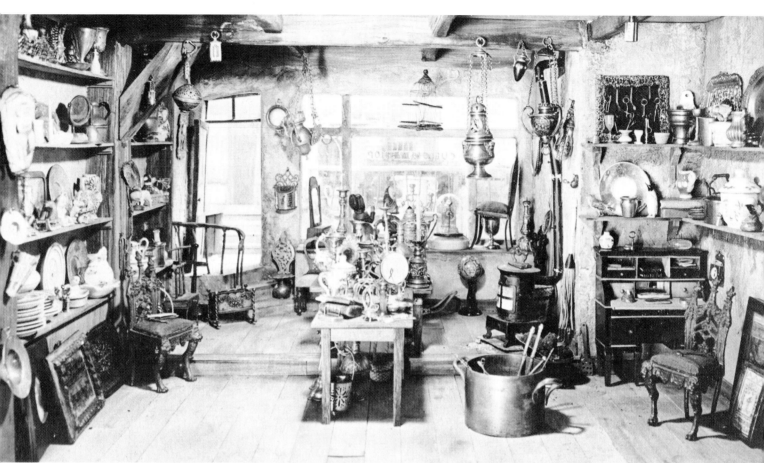

23.
Over five hundred antiques from six countries and three centuries were assembled by Helena Rubinstein to furnish this miniature replica of Charles Dickens's imaginary "Old Curiosity Shop." French, c. 1920s. Height: 41.3 cm. (16½ in.). Tel Aviv Museum

24.
The "Montmartre Studio" is another miniature room created by Helena Rubinstein. This airy attic apartment includes all the trappings of Parisian artistic life: a still life of bottles and fruit carefully set upon the table, plaster casts of figures and unframed canvases leaning against a wall. French, c. 1920s. Height: 45 cm. (18 in.). Tel Aviv Museum

Vernon, Andrew Jackson's Hermitage and Jefferson's Monticello, the Jeremiah Lee Mansion (colorplate 8) and the Hammond-Harwood House (see frontispiece). The miniature drawing room of the Jeremiah Lee Mansion is paneled in fine wood, and its style reflects the influence of the English architect Sir Christopher Wren (1632–1723). The original mansion was built in Marblehead, Massachusetts, during a prosperous period for the fishing industry, and its rich furnishings, including the wood paneling, are said to have been made in England and shipped to America at great expense. The dining room of the Hammond-Harwood house also exhibits the late-eighteenth-century American predilection for English architectural styles but shows a southern sensibility in its spaciousness and elaborate decorative detail.

One of the composite rooms, a hallway of a San Francisco penthouse, presents in miniature a contemporary room in the international style (colorplate 9). Paintings, drawings and sculpture after Jean-Victor Hugo, Marie Laurencin, John Storrs, Amédée Ozenfant and Léopold Survage decorate the neutral-colored walls, while modern chairs with clear Lucite legs, a veneered coffee table and other characteristic pieces have been chosen for furnishings. Through the open French doors can be glimpsed Treasure Island and the twinkling lights of the Bay Bridge.

OVERLEAF
Colorplates 6, 7, 8 and 9.
In the marvels of miniature perfection known as the Thorne Rooms, proportions have been meticulously adjusted to the eye, and the rooms have none of the topsy-turvy, Alice-in-Wonderland scale of toy dollhouses. In all, Mrs. Thorne constructed and furnished ninety-seven rooms.
Upper left: Tudor Great Hall. Height: 57.8 cm. (23⅛ in.).
Lower left: Chinese interior. Height: 57.8 cm. (23⅛ in.).
Upper right: Drawing room of the Jeremiah Lee Mansion, Marblehead, Massachusetts, 1768. Height: 30 cm. (12 in.).
Lower right: Hallway of a San Francisco penthouse apartment, 1940s. Height: 33 cm. (13¼ in.).
American, 1933–42. The Art Institute of Chicago

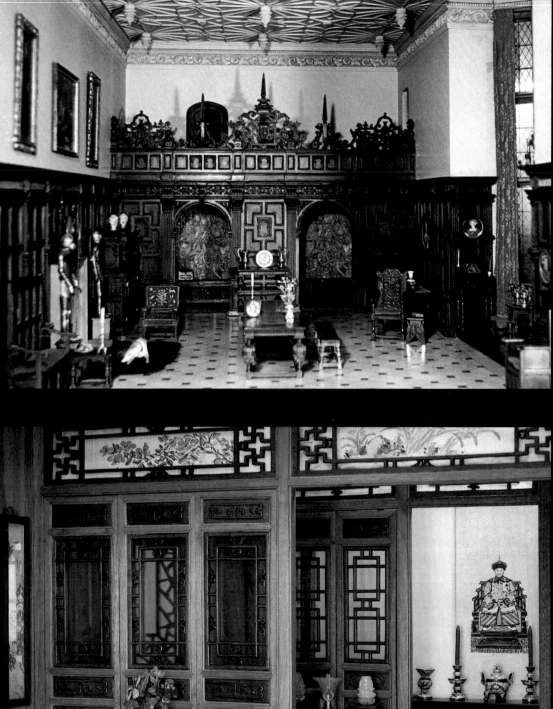
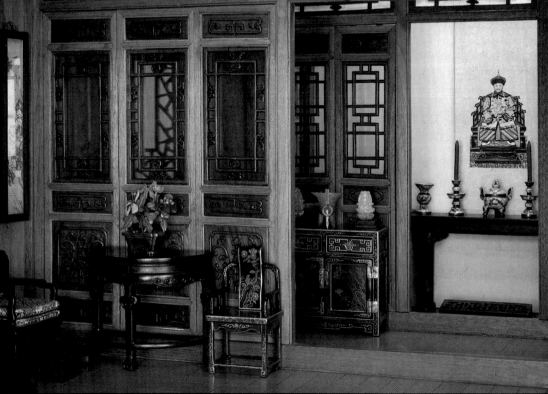

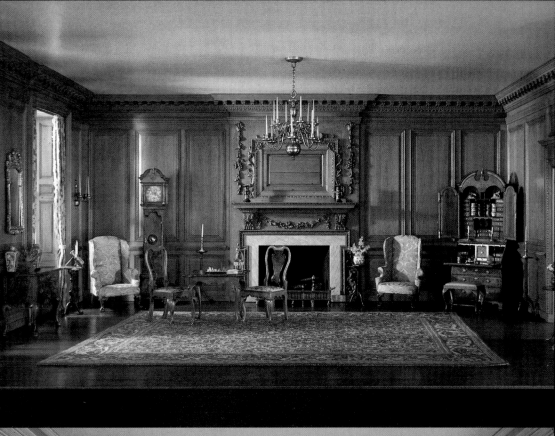
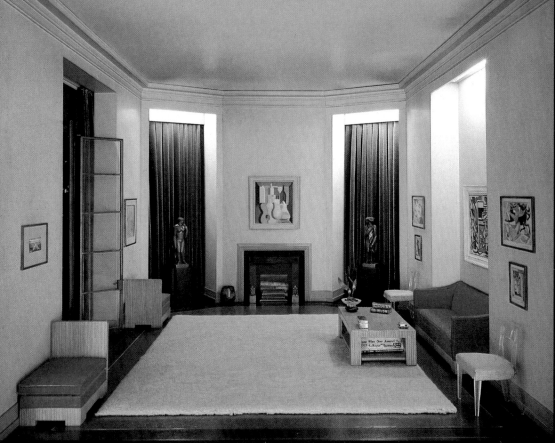

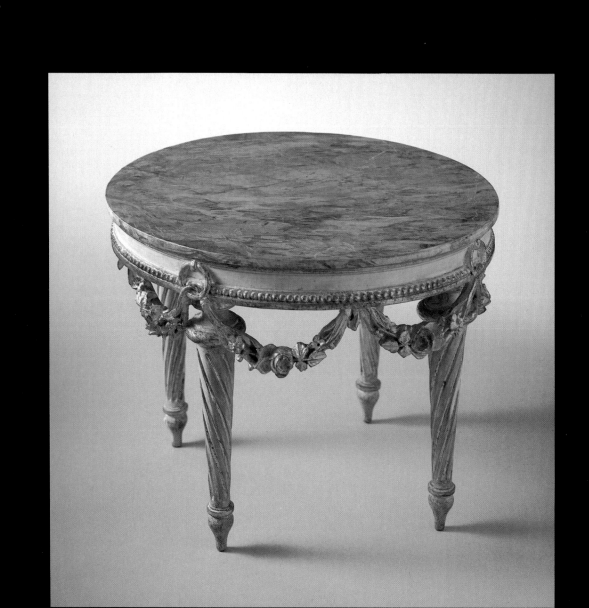

3 Furniture

To anyone who has ever longed to possess a full set of Chippendale chairs or yearned to decorate a room perfectly down to the last detail, collecting miniature furniture can be the fulfillment of a dream. Space considerations, usually one of two ultimate determinants of whether or not one acquires a full-size piece of furniture (the other being cost), cease to be important when collecting miniatures. Room can almost always be found for one more tiny sofa, one more diminutive bed or chest.

Collecting miniature furniture has been a pastime in Europe and America for over three centuries now. Some of the finest pieces of miniature furniture produced to date were made in Holland in the seventeenth and eighteenth centuries (plate 25) to furnish the rooms of *poppenhuizen*, or Dutch cabinets (see plates 6 and 7). The tables, chairs, beds, cupboards and chests made for these little rooms, although only one-twelfth as large as full-size furniture, were crafted of the finest woods, and required the same woodworking skills— joining, carving, inlay techniques and polishing—used in the construction of their full-scale models. So exquisitely made and so realistic were these little renditions of the Dutch furniture of the day that they set the standards for all subsequent miniature furniture.

It is thought that Charles II of England saw and was impressed by these early Dutch miniatures while he was in exile on the Continent. After his restoration to the throne in 1660, the quality of workmanship in English miniatures improved, and the craftsmen began to make beautiful little copies of contemporary furniture styles. This change was perhaps a reflection of a larger development that was taking place simultaneously in the design of full-scale furniture in England. From

Colorplate 10.
It is often hard to date miniature furniture with certainty. This little marble-topped table bears no signature or other identification marks, which makes it difficult to say whether it was made in the eighteenth or nineteenth century. The carving, especially of the gilded swags festooned with flowers around the apron of the table, and the tapered painted and gilded legs suggest the style of the late eighteenth century, although it could be a later piece made in the earlier style. Probably Italian, c. nineteenth century. Height: 18.4 cm. (7⅜ in.). Cooper-Hewitt Museum

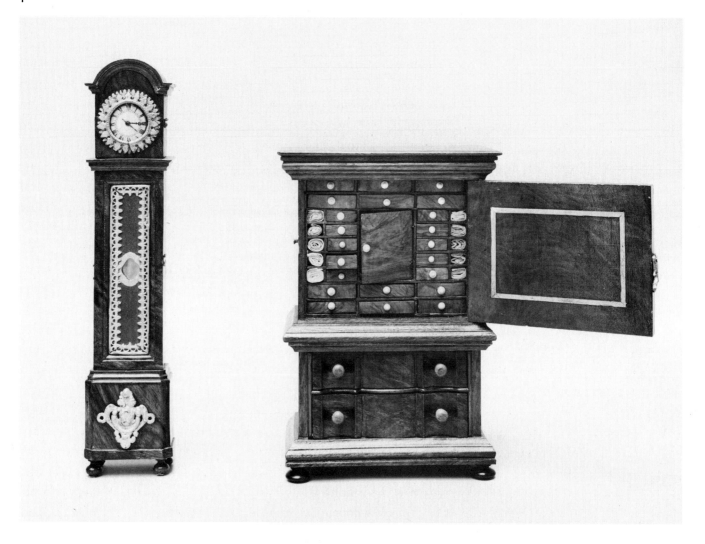

25.
The furniture made for the early Dutch cabinet houses was so exquisitely beautiful and so carefully crafted that it set standards for the production of miniature furniture that still hold today. This cabinet and case clock are from the Sara Ploos van Amstel House (see plate 7), c. 1743. A small seashell collection is stored in the drawers of the miniature cabinet. Dutch, Amsterdam, c. 1743. Height: 15 cm. (6 in.). Gemeentemuseum, The Hague

the time of Henry VIII, the English aristocracy had furnished their homes with rather heavy medieval furniture that incorporated elements of Renaissance ornamentation. When Charles returned, full of admiration for the new baroque designs he had seen on the Continent, and particularly for those of the Dutch, his countrymen began to develop a taste for the new style. This taste was further strengthened in 1689 when James II was exiled to France, and William III, Prince of Orange, and Princess Mary, daughter of James, ascended the English throne. High-back walnut chairs fitted with cane backs and cane seats, often made *en suite* with daybeds, were a part of this new look and were eagerly acquired by the pacesetters of the day (plate 26).

The French, who seem never to have been afraid of luxury, have been prolific in their production of fine miniature furniture. Beginning in the seventeenth century, and arriving at a pinnacle of achievement

during the eighteenth, the French crafted miniature pieces very much like their real-life counterparts: of exotic woods, including mahogany, walnut and fruitwood, with marble surfaces and ormolu, or gilded bronze, fixtures. Constructed by a number of craftsmen—specialists in veneers, *ébénistes*; carved pieces, *menuisiers*; inlay work, *marquetteurs*; lacquering, *laqueurs* and gilding, *doreurs*—the verisimilitude evoked by attention to detail and accurate proportioning has made these pieces favorites with collectors for over two hundred years.

The term "miniature furniture" is commonly used to refer to several different sizes of small furniture: dolls' furniture, made for a dollhouse or simply for a doll's use, is generally the smallest (a chair might be no more than several inches tall); scale furniture can be considerably larger, depending on the reason for its reduction. The furniture of the Thorne Rooms, for instance, was reduced in accordance with the size of the rooms, on a scale of one inch to a foot (see colorplate 16). Models made by architects and furniture designers frequently fall into this category by virtue of their size. Children's furniture technically is not miniature at all, since it is of adequate dimensions for a child's use and thus constitutes full-scale children's furniture.

Frequently it is very difficult to tell by looking at a piece of miniature furniture why it was made in the first place. Dollhouse furniture is an exception, obviously, since it can usually be recognized by its size and is often found and sold with the house for which it was made. But with furniture in the in-between sizes, the true miniature furniture, unless documents exist to relate the history of the piece (and that occurs very rarely), it is often impossible to say with any certainty who made it or how it was meant to be used.

Of the various theories that have been bandied about over the years to explain the existence of these little showpieces of woodworking skills, two explanations have been popular: that miniature furniture was intended to be used as salesmen's samples, or that it was made by apprentices. Those who support the first explanation rightly point out that small models would be light and portable for the traveling salesman, who could hardly cart around full-size samples of a cabinetmaker's output. Those who support the second explanation—that the miniatures were the final models built by apprentices to prove their competence at the end of their service—reason that fewer materials would be needed to construct a test piece in miniature, and that the apprentice would have built in small scale for reasons of economy.

Some authorities insist that neither of these explanations is likely. Herbert Schiffer, an expert on American miniature furniture, gives several compelling reasons for concluding that "ninety-nine percent [of the American pieces he has examined] fall into neither category."

26.
Energetically carved with scroll motifs and with baluster-turned uprights, this walnut chair with caned seat and back is an accurate miniature rendition of a baroque chair style popular in England in the second half of the seventeenth century. A pillow would have been used for extra comfort on the caned seat. The cresting has suffered damage. English, 1650–1700. Height: 34.4 cm. (13¾ in.). Bethnal Green Museum of Childhood, London

27.
Carved and gilded in the manner of the late seventeenth century, this armchair was in fact more likely made later for someone who was creating a seventeenth-century "period" room. Italian, 1800–1900. Height: 20.6 cm. (8¼ in.). Cooper-Hewitt Museum, gift of Eleanor and Sarah Hewitt

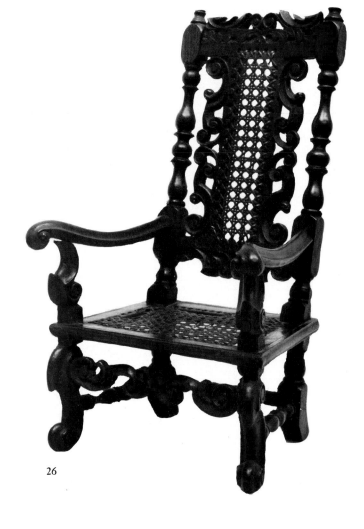

26

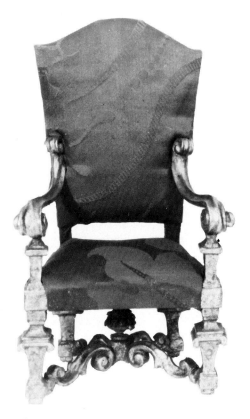

27

He rightly points out that although fewer materials would be consumed in the production of a miniature rather than a full-scale master piece, the amount of time and labor involved to produce the little work would be about the same, making it unlikely that either an apprentice or his master would bother with a small piece that could never bring full compensation for his efforts when sold. Further, although the skill needed to produce most of these miniature pieces was considerable, frequently the proportions of the furniture are incorrect, which would suggest that if they were test pieces, their makers probably did not move on to become masters. As for the notion that miniatures were made as salesmen's samples, it is certainly true that miniature furniture is more portable than full-size, but there are no records indicating that traveling salesmen transported even miniature furniture. The usual way of buying furniture in American cities in the eighteenth century was to import it from Europe—a costly proposition—or to go to a local cabinetmaker and tell him what was

needed. Together the cabinetmaker and customer worked out details of style, selected a wood to be used, and settled on the size of each piece. Several weeks later, the furniture would be ready. In rural areas, where transportation was difficult, furniture had to be made locally or supplied by an itinerant carpenter or peddler. Lambert Hitchcock, a Connecticut cabinetmaker, supplied chair parts—backs, legs and rungs—to such traveling peddlers who, with a few simple tools, managed to assemble Hitchcock's chairs on the spot for farm families. Woven rush seats were added later, since wooden seats would have been too bulky for the peddler to carry.

Mrs. Margaret B. Schiffer has contributed her own interesting research in support of her husband's theories. Of the eleven thousand wills she examined from Chester County, Pennsylvania—an area that has provided us with a wealth of carefully constructed miniature furniture—not one makes mention of miniature furniture. Presumably, both salesmen's samples and apprentices' models would be deemed valuable enough to be passed on to one's heirs. Toys, on the other hand, whether for children or adults, more than likely would be overlooked in drawing up a will.

The fact that most miniature furniture seems to have been made during times of prosperity also lends credence to the belief that these little creations had nonutilitarian functions. The seventeenth-century colonists, for instance, although they were aware of the tradition of miniature making, have left us few examples of their work. A century later, when the basic needs of this new country had been attended to, there was an outburst of the craft in several areas along the Eastern seaboard, including Massachusetts, Connecticut, New York, New Jersey and Pennsylvania.

Not only has it been difficult to determine why miniatures were made; it is usually well-nigh impossible to discover who made them. Almost all miniatures are unsigned. Frequently, however, the workmanship of a piece is of such high quality that we assume only a craftsman of the highest caliber could have been responsible for its creation. And usually there is speculation about who this craftsman was. As already noted, speculation had it that Thomas Chippendale, England's renowned furniture- and cabinetmaker, created the very beautiful furniture in the dollhouse at Nostell Priory. The attribution is based on the fact that Chippendale grew up in Osley, about thirty miles from Nostell Priory, and may have made the miniature furniture before leaving his boyhood home for London.

Later in life, Chippendale did make furniture for the "great House" at Nostell Priory, for which the family retains the receipts, but there

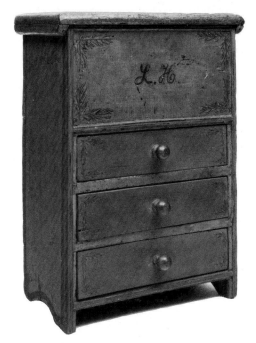

28.
This miniature blanket chest has been colorfully painted in green, with red outlining around the lid and sides and decorative leaf stalks in red, yellow and black on the corners of the drawers and the front of the blanket well. The script initials *L.H.* have been painted on the front in black outlined in red. American, probably Pennsylvania, c. 1820–40. Height: 36.88 cm. (14¾ in.). The Henry Francis du Pont Winterthur Museum, Winterthur, Delaware

is no documentation supporting the claim that he made the miniature furniture too. Tradition also has attributed other exceptionally fine miniature pieces of furniture in the Chippendale style to the great master. Some of the furniture in Helena Rubinstein's rooms is said to have been made by Chippendale, as is that in the dollhouse at Cane's End, an estate near Reading which was originally a country house for the monks of Notley Abbey. But nowhere is there any proof. Chippendale is not the only cabinetmaker to have aroused such speculation; similar legends about other noted furniture makers abound.

Several well-known French craftsmen, however, are thought to have created miniature pieces of furniture. Martin Biennais (1764–1843) has been credited with fine miniature designs as well as with exquisitely crafted *nécessaires*—small boxes that contained personal articles and were often shaped like the utensils they held—objects very much like miniatures in the exacting craftsmanship they required. The *ébéniste* Etienne Nauroy (active in Paris 1765–87) is recognized for a luxurious canopied bed of gilded wood and damask silk in the style of Louis XVI, with rich, fringed edging and gold braid, topped with ostrich plumes. The pride taken in this tiny masterpiece is evidenced in the careful attention lavished on it and in the choice of elegant and expensive materials. Etienne Levasseur, another French craftsman whose name is connected with a love of rich materials and costly woods, is believed to have made a beautiful miniature table, in the elegant Louis XVI style, of several kinds of woods including a deep ebony veneer. The table was then decorated with gilt bronze fleur-de-lis and cherubs and, finally, each edge was outlined carefully in gold.

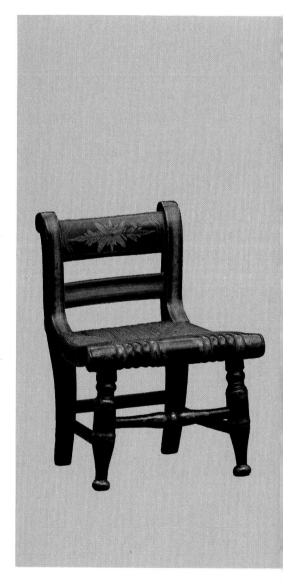

Dating miniature furniture is also problematical, for although miniature furniture generally reflects styles popular in full-scale furniture at the time, and frequently displays a regional character, a lag usually occurred between the appearance of a style and its manufacture in miniature. Compounding this difficulty is the fact that one of the joys of furnishing miniature houses and rooms is the possibility of re-creating settings from the past: period rooms, rooms from literature or rooms fondly remembered from one's childhood. To do this, one must acquire "period" miniature furnishings; and if there are no genuine antiques to fill the bill, it is necessary to create furnishings that appear to be much older than they are (colorplate 10 and plate 27). Miniature objects in the *Chippendale, Duncan Phyfe, Sheraton* and Victorian styles and their many variations (colorplate 11), have a particular appeal for American collectors, and many miniaturists continue to make pieces in these styles to accommodate today's demands.

Colorplate 11.
This small wooden slat-backed settee, part of a set with two matching chairs, has seats of woven rush. Furniture in this style, nearly always painted in black or red with gilt trim, was also popular in a larger size that could actually be used by children. American, c. 1810–50. Height of chairs: 20 cm. (8 in.). The Henry Francis du Pont Winterthur Museum, Winterthur, Delaware

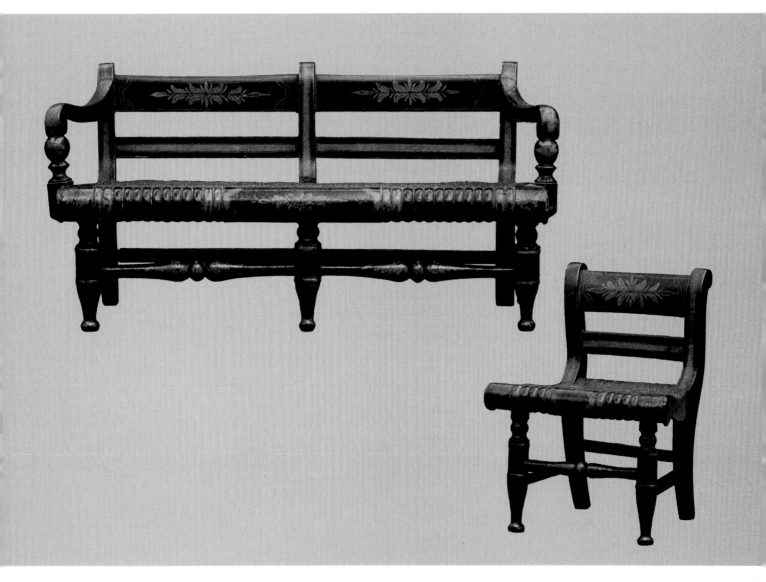

Miniature country furniture, farmhouse furniture or furniture of obviously ordinary circumstances rarely invites this kind of speculation about its past. Although much of the miniature country furniture has an abundance of character and charm, generally the workmanship is not of such high quality that it suggests important parentage. We automatically assume that most of these pieces were made by a local carpenter of little repute, or perhaps by a doting father or grandfather. Interestingly enough, these simple pieces are often the ones that give us clues to their history: they are frequently monogrammed (plate 28) or painted with local scenes (colorplates 12, 13 and 14 and plates 29 and 30), or they bear a simple inscription such as: "For Caroline from her grandfather."

The *Windsor chair* is an example of a simple form that has been popular with miniaturists of varying woodworking abilities, much like its larger prototype. The chair was introduced to the colonies from England in the eighteenth century and has remained in production in the United States ever since. It can be found in numerous miniature variations, from brace-back, continuous arm, bow-back and fan-back to comb-back, hoop-back (plate 31), duckbill and butterfly.

Colorplates 12, 13, 14 and Plates 29 and 30. Although this miniature pine and poplar chest of drawers seems at first look to be a simple piece of furniture, its maker put thought into its construction: the front of the chest has a projecting top drawer supported by a pair of columns of a design similar to those shown in a *trompe l'oeil* painting of Dartmouth Library on the back of the chest. The lid (opposite, top), is engagingly painted with a design probably taken from an early print made of Dartmouth College by Nathaniel Currier before his partnership with James Merritt Ives. Each side panel (opposite, bottom) has been painted with a whimsical scene, one of a dancing female figure, the other of affectionate puppies. American, New Hampshire, c. 1840. Height: 52.7 cm. (21½ in.). Smithsonian Institution, Washington, D.C.

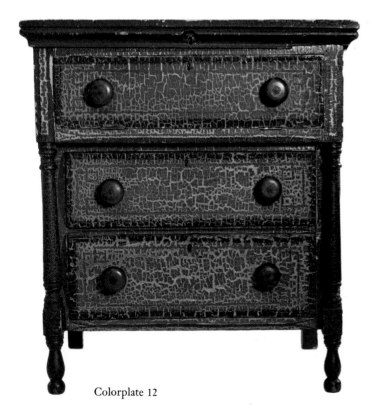

Colorplate 12

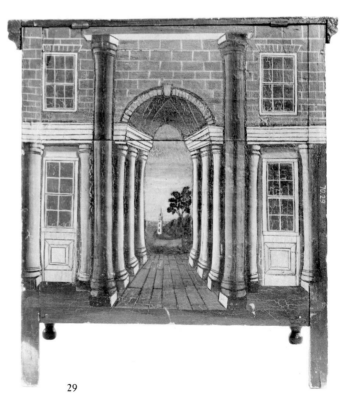

29

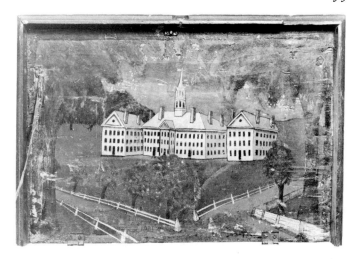

30

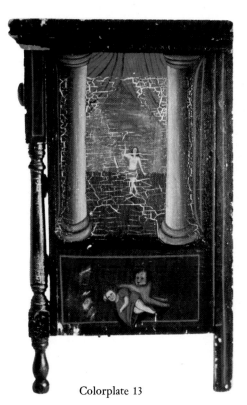

Colorplate 13

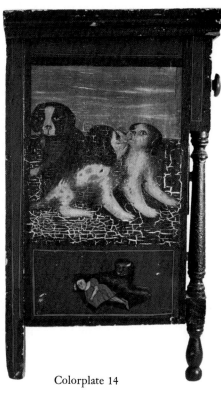

Colorplate 14

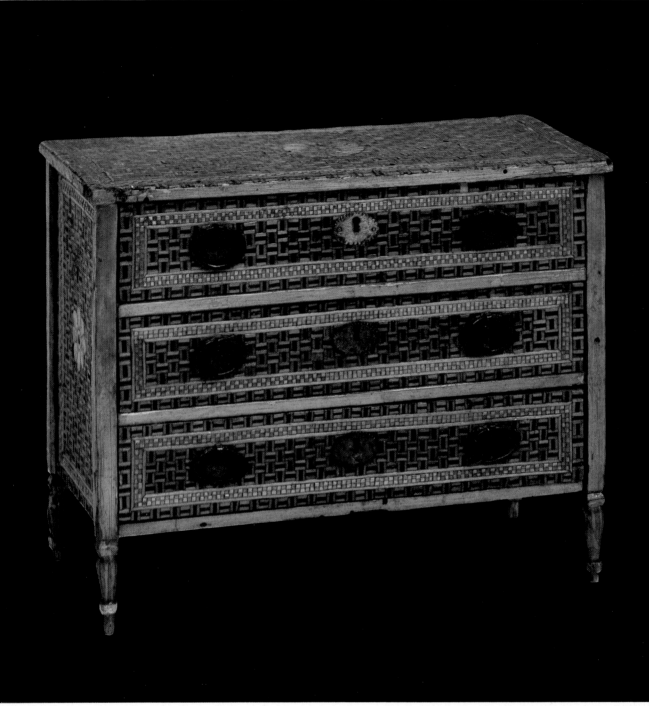

Whatever one's preference in styles, there is a profusion of miniature furnishings to choose from. Chests are traditionally among the most prized pieces of furniture, symbols as they so often are of hope. And they have been one of the miniaturist's most popular creations. There is the fiancée's hope chest, the expectant mother's blanket chest, the family chest of drawers and a variety of other chests whose charm is obvious but whose purpose is no longer apparent to us (colorplate 15). The fact that even diminutive chests can be used for "storage" undoubtedly accounts for some of their popularity with the miniaturist and the collector. There is little one can do with a miniature chair, for instance, except display it, but a miniature chest can be used to hold jewelry, stamps, stationery, coins and other small objects.

Beds, along with their coverings, have received the miniaturist's attention, and deservedly so, for they were one of the more expensive pieces of furniture purchased by a young couple setting up a house. After buying the frame from a cabinetmaker, it was necessary to acquire a mattress, a bolster, sheets, blankets, coverlet and fabric for the skirt, the canopy and the curtains. Although there were practical reasons for this assemblage (the canopy and curtains kept out drafts, for instance), it also served as an indication to others of the owner's wealth, for the bedroom sometimes doubled as a sitting room in the eighteenth century. Obviously, furnishings of such significance would warrant the attention of the miniaturist (plates 32–39).

As for the rest of the furniture needed to decorate a miniature house, many examples also can be found: footstools, mirrors, cradles (plate 40), washstands (plate 41), chairs and sofas.

Some of the more highly prized American miniatures are the works of cabinetmakers of the eighteenth and early nineteenth centuries. Lovely miniatures can be found in all of the important styles of these distinguished periods. Chests (plate 42), chairs, tables, clocks and dressing tables (plate 43) appear in the Queen Anne and Chippendale styles; these miniature copies even display the regional variations in decorative motifs and styling that developed in the full-size furniture made in the colonies. Later in date are the elegant miniatures in the *Federal style* (plate 44), with their delicate inlays of contrasting woods, and the heavier, more ornate *Empire* pieces (plate 45).

Duncan Phyfe (1768–1854), the Scottish furniture maker who emigrated to New York in 1792 and became extremely successful, developed a modified and restrained Empire style that has appealed to Americans both in its full-scale form and its miniature versions for well over a century now. In fact, this particular style has been so popular with dollhouse owners that countless manufacturers turn out what is known as "Dollhouse Duncan Phyfe." Such pieces, of course,

Colorplate 15.
This miniature chest of drawers is made of wood covered with various colors of straw woven in basketwork and checkerboard patterns and has brass pulls and brass escutcheons. Each drawer is a little more than an inch in height. Italian, c. 1820. Height: 10.93 cm. (4⅜ in.). Museum of Fine Arts, Boston, gift of Mr. and Mrs. John Bombaci. *Shown actual size.*

31.
Although many miniatures are faithful replicas of full-scale models, this miniature Windsor chair has only three spindles, whereas a full-scale Windsor chair would have anywhere from seven to eleven. Traces of white paint can be found on the piece, indicating that it has been stripped and refinished. American, New England, c. 1765–1810. Height: 28.13 cm. (11¼ in.). The Henry Francis du Pont Winterthur Museum, Winterthur, Delaware

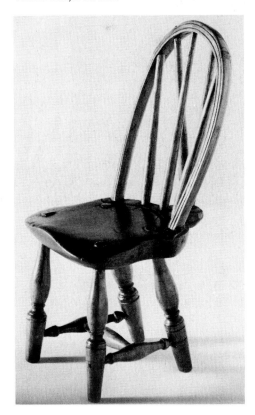

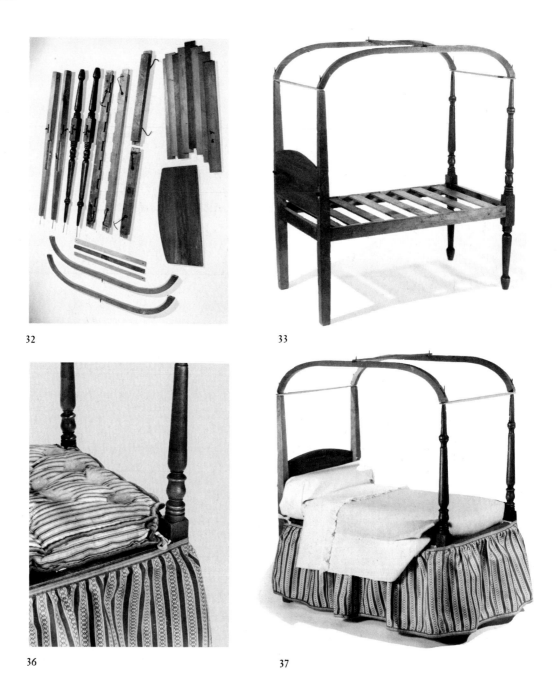

32

33

36 37

32–39.
The eighteenth-century four-poster bed was one of the more costly purchases in furnishing a home, for in addition to purchasing the bed from a cabinetmaker, lengths of fabric had to be bought for the mattress ticking, pillow, bolster, sheets, blankets, coverlet, skirt, canopy and curtains. American, eighteenth century. Height: 37.5 cm. (15 in.). Greenfield Village and Henry Ford Museum

are only crude imitations of real Duncan Phyfe furniture or well-made Duncan Phyfe miniatures. The less formal style of some of Thomas Sheraton's (1751–1806) designs has also been popular with miniaturists. Works that evoke the Sheraton style have been reproduced countless times in both miniature and children's sizes. The *slat-backed settee*, usually with rush seats and often with matching chairs, has also been a long-time favorite (see colorplate 11).

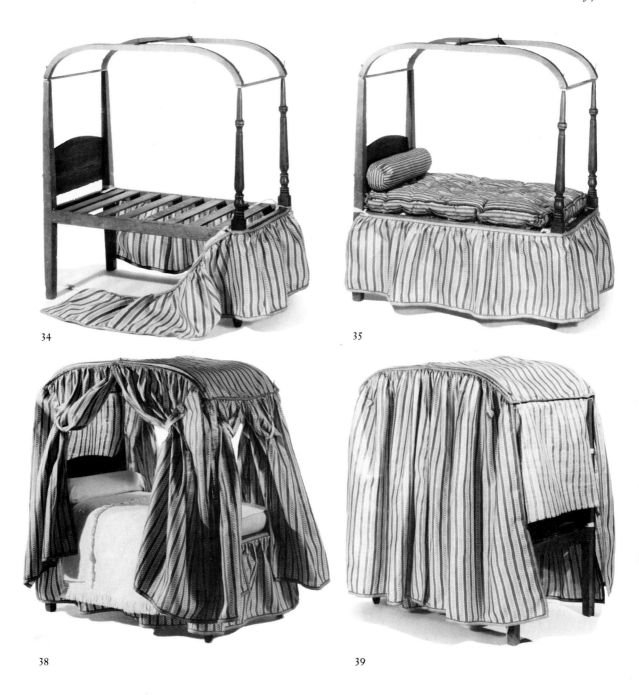

34

35

38

39

Inevitably in the second half of the nineteenth century industrialization invaded the world of the miniaturist, and factories in the United States, England and Europe began mass-producing dollhouse furniture that was entirely devoid of the individuality and charm of the earlier handcrafted examples. These mass-produced pieces do, however, accurately reflect production methods of the day in that individually handcrafted furniture had become a rarity in most homes by the end

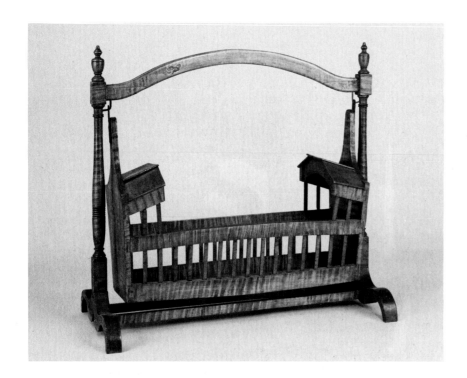

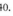

40.
The pleasing lines of this miniature cradle, as well as the beauty of the striped maple chosen for its construction, are indications of the care that went into its design. American, Pennsylvania, late eighteenth century. Height: 46.25 cm. (18½ in.). Yale University Art Gallery, New Haven, Connecticut, Mabel Brady Garvan Collection

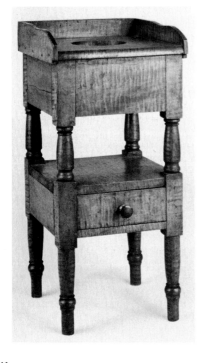

41.
Although this little unpretentious washstand has a simple, sturdy appearance, a fine piece of striped maple was chosen for its construction. American, New England, 1810. Height: 36.8 cm. (14¾ in.). Yale University Art Gallery, New Haven, Connecticut, Mabel Brady Garvan Collection

of the century. Large furniture manufacturers turned out entire dining room sets, living room sets and bedroom sets in various revival styles, which were stored in gigantic warehouses until sold in furniture stores. In this sense, the mass-produced miniatures are indeed "true to their time."

A boon to miniature collectors occurred in 1836 when the United States Patent Office would not accept a patent application unless it was accompanied by a model of the invention. From 1836 until 1880, while the requirement was in effect, the U.S. Patent Office accumulated several hundred thousand models of inventions for the proposed betterment of nearly every aspect of modern-day living. Among these small-scale models can be found such utilitarian inventions as washing machines, carpet sweepers, heating stoves, folding cots, lace-curtain dryers and other new-fangled furniture and appliances. Many of the models were later sold by the Patent Office, and they, along with manufacturers' prototypes and other working models (plate 46), can make interesting additions to a collection of miniatures, or, indeed, may form its very core.

There were also, of course, those rare individuals who continued to make miniatures by hand, for the sheer joy of rendering a favorite piece of furniture on a small scale. The Victorians, great lovers of secrets, were masters at making desks, both full-size and miniature, with hidden compartments, drawers and cabinets. Slant-top desks,

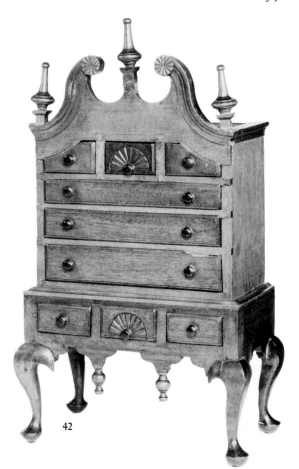

42

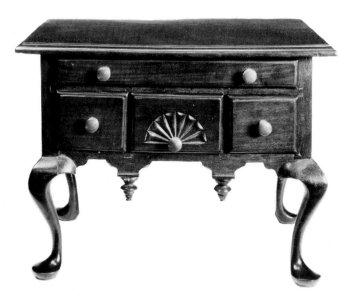

43

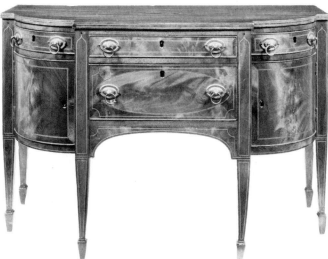

44

42.
If a piece of miniature furniture has been carefully designed, it is usually impossible to tell from a photograph whether the piece is miniature or full-scale. In contrast, there is something unexpected about the proportions of this walnut chest of drawers that lends it an air of whimsy. American, Connecticut, c. 1750–80. Height: 45 cm. (18 in.). The Henry Francis du Pont Winterthur Museum, Winterthur, Delaware

43.
The exaggerated curve of the cabriole legs of this miniature pine and mahogany dressing table give it an animated appearance. American, New England, c. 1725–50. Height: 22.5 cm. (9 in.). The Henry Francis du Pont Winterthur Museum, Winterthur, Delaware

44.
Tradition has it that this miniature Federal-style sideboard was owned by William Monroe, the maker and inventor of lead pencils in the United States. Mahogany and pine were used for its construction. American, probably Concord, Massachusetts, c. 1790–1810. Height: 34.7 cm. (13⅞ in.). The Henry Francis du Pont Winterthur Museum, Winterthur, Delaware

though slender and not very deep, almost always have many more cubbyholes for tiny writing implements and paper than one would imagine. And some of the more charming nineteenth-century pieces are fine miniature examples of the upholsterer's art (plate 47).

In our own century, production of miniature furniture seems to occupy more hands than ever before. The quality of these recent pieces varies considerably, however, depending primarily on the reasons for their manufacture. Today considerable energy has been channeled into supplying the demand for children's dollhouse furniture. This furniture is, for the most part, mass-produced and totally lacking in beauty, authenticity and inspiration. Alongside, there exists a trickle of beautiful and worthwhile creations, the work of craftsmen of the highest order who have produced their tiny masterpieces for a variety of reasons—some traditional, some new with our age.

Various craftsmen from around the world assisted Mrs. James Ward Thorne in furnishing the ninety-seven miniature period rooms she designed between 1933 and 1942. One, Eugene Kupjack—master craftsman of the third group of Thorne rooms, presented to the Art Institute of Chicago in 1942—deserves special note. He began his collaboration with Mrs. Thorne after he sent her a miniature Jacobean stool crafted from cane, a very difficult material to work on such a tiny scale. Mrs. Thorne, who had been at a loss to find someone who could supply her with a cane piece, was so impressed that she gave

45.
Built of mahogany, cherry and white pine, with horsehair upholstery and winged-eagle and paw feet, this Empire-style sofa was *au courant* when it was made during the first decades of the nineteenth century. American, probably New York, c. 1820–30. Height: 36.88 cm. (14¾ in.). Yale University Art Gallery, New Haven, Connecticut, Mabel Brady Garvan Collection

46.
Dr. Ira Allen Salmon, a dentist in Boston and a lecturer at Harvard, made this miniature dentist's chair of wood and brass. Green silk upholstery, a decorative fringe around the base of the seat and swan's-head arm terminals lend an elegant air. American, Boston, c. 1868–77. Height: 30.6 cm. (12¼ in.). The Henry Francis du Pont Winterthur Museum, Winterthur, Delaware

47.
Overstuffed furniture such as this miniature red damask pouf, which is deeply tufted and fringed, its flowing lines accentuated by white piping and braid, is the hallmark of Victorian comfort and elegance. The pouf was made by Albert Bentley, upholsterer at Buckingham Palace, as part of a suite of miniature furniture. English, nineteenth century. Height: 18.4 cm. (7¾ in.). Bethnal Green Museum of Childhood, London

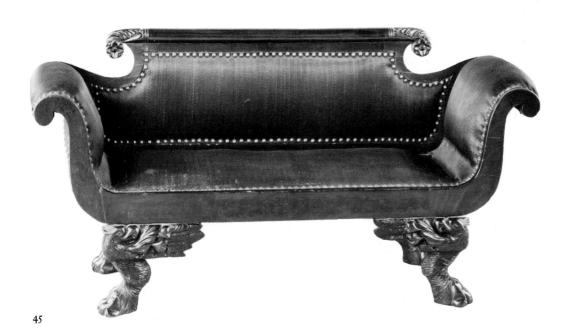

45

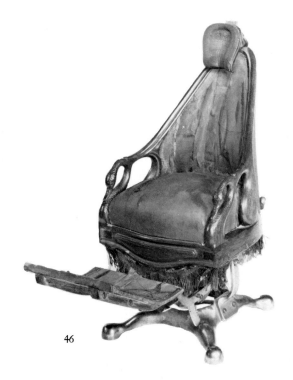

46

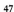

47

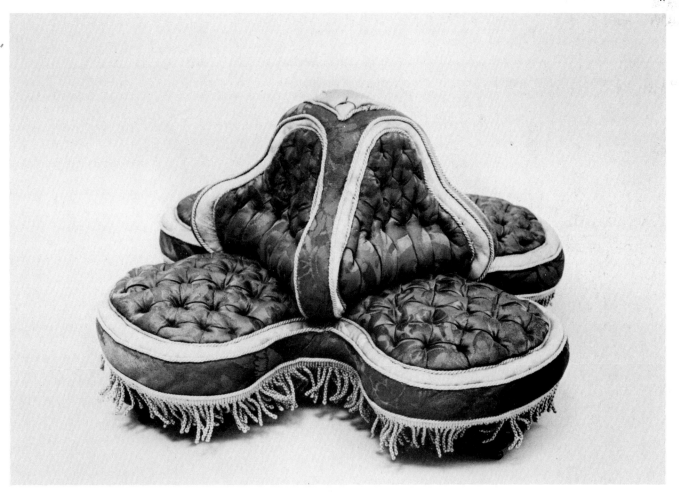

him a full-time job on the spot. Kupjack immediately set to work on the series of American rooms, laboring three-and-a-half years to produce thirty-seven interiors. He created most of the furniture, accessories and ornately carved miniature moldings, scrupulously reducing them to one-twelfth their actual size. He carved paneling for the eighteenth-century Hammond-Harwood drawing room (see colorplate 8) and fashioned chairs with Lucite legs and yellow silk upholstery for the San Francisco penthouse hallway (see colorplate 9).

More recently, miniature interiors and their furnishings have been exquisitely crafted for purposes quite apart from the appreciation of fine workmanship and historical accuracy alone. In a process known as matting, miniature settings have been utilized by the motion-picture industry to replace costly full-size period backgrounds. The actors are filmed against a bare backdrop, and the film of the action is then superimposed over a miniature setting. The scale and historical detail must be absolutely accurate in order to create the illusion of the real setting, and some of the finest contemporary miniaturists have been called upon to create furnishings for these "sets." It is ironic that with this commercial and highly technological venture, we once again return to that wondrous thought of childhood—that tiny places can grow large enough for grown-ups to inhabit.

Much of the miniaturist's attention in this century appears to have been focused on creating copies of furnishings from earlier periods—a development due in part to the demands and tastes of today's collector. It should be remembered, however, that the craftsmen who supplied Anna Köferlin, Petronella de la Court, Petronella Oortman, Sara Ploos van Amstel and Lady Winn with miniature furnishings were copying styles and designing interiors in vogue at the time. In so doing, they provided us with valuable documents of the way they lived. Likewise a faithfully made miniature Barcelona chair and a little Frank Lloyd Wright bench created now will be to the future historian and collector what those earlier creations are to us.

Faced by such a diversity of styles, not to mention the countless objects that have been crafted in miniature, the most difficult problem for the collector is probably how to settle on one style, or to choose between one chair and another when there are so many possibilities. But perhaps this is the luxury of working in miniature. For if one decides to decorate a room in Chippendale, only to discover a year later that Victorian furniture suddenly seems irresistible, what is to prevent one from starting all over again and making one more try at creating that perfect room?

Colorplate 16.
The Empire style is beautifully exemplified in this selection of furniture from the miniature French salon created by Mrs. James Ward Thorne. Imperial splendor and symbolism are apparent in the contrast of strong color against gilded surfaces and in the combinations of historical motifs meant to glorify the reign of Napoleon. Egyptian details, such as the gilded sphinx busts that decorate the chairs, were freely mingled with Roman statuary in interiors of the era, with obvious reference to earlier empires. American, 1933–42. Height of chair: 7.5 cm. (3 in.). The Art Institute of Chicago

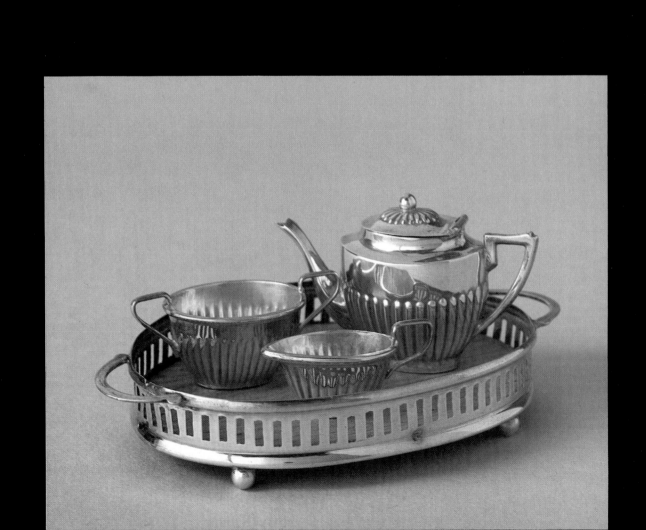

4 Silver

Some of the most highly refined miniature objects are those made of silver, porcelain and glass—Lilliputian equivalents of the masterworks of the great European and American silversmiths, potters and glassworkers. The tradition of working silver in miniature developed early in the history of the craft and was a natural outgrowth of the silversmiths' regular production, which included small coins and medals, vials, jars, small sculpture and jewelry.

The techniques used to make miniature silver are essentially the same as those used to make larger objects. To produce a hollow vessel, for instance, the silversmith begins with a flat sheet of silver. The vessel is gradually *raised* from this flat sheet by shaping its sides over the curves of the anvil. As the sides grow higher, they begin to curve inward and over the bottom, and the pot slowly starts to take shape. Finally, the hammered metal is carefully smoothed and polished to a mirror gloss.

The miniaturist metalworker must be constantly aware of the thinness of the metal he is working. When a silver teapot is scaled down by a factor of one to twelve, the metal becomes very thin indeed. In shaping, it is not the village blacksmith's brawny arm that is called for, but the light tap of someone endowed with both delicacy and patience.

Another metalworking technique used by silversmiths working in full scale and in miniature alike is that of casting by the *cire perdue*, or *lost wax*, method, a process employed in Egypt by 2500 B.C. This involves the sculpting in wax of a model of the object to be cast, in full detail. The wax model is dipped repeatedly in liquid clay, until it is thoroughly coated. It is then dried and plastered all over with a thick

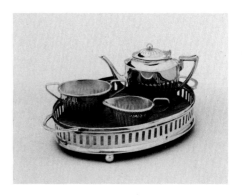

Colorplate 17.
Composed of a teapot, creamer, sugar bowl, tray with oak base and two cups and saucers (not shown), this miniature tea set bears the maker's mark: *CS*FS* (for Saunders and Shepherd). English, Chester, 1913–14. Height of teapot: 3.2 cm. (1¼ in.). Cooper-Hewitt Museum, anonymous gift. *Shown (above) actual size.*

coating of clay. Wax rods fixed to the model lead through the clay to the outside to create channels for pouring in molten metal. Finally, the whole is baked in an oven so that all the wax melts or burns out —hence the name "lost wax." Left inside is a perfect mold of the model. When molten metal has been poured in and has cooled, the clay is broken away and the finished sculpture revealed. One of the drawbacks of the lost wax method is that the original model is destroyed. In sand casting, which is also used by miniaturists, the model is reusable. Sand casting is utilized to produce details such as thumbpieces and handles, as well as small sculptures.

Institutionalized systems of marking silver developed across Europe and in England as early as the sixteenth century; thanks to these systems, silver miniatures are not bedeviled by all of the problems surrounding the provenance of other miniatures. Frequently a particular work bears a maker's mark identifying the silversmith who made it; a date letter indicating when it was made; a city mark or province mark recording where it was made and a *hallmark*, or quality mark, certifying the purity of the metal.

Nor is the question of why silver miniatures were made, or how they were intended to be used, as elusive as for some of the other miniature forms, although differences of opinion do exist.

As in the case of furniture, many commentators in the past have suggested that silver miniatures either served as salesmen's samples or were training works made by apprentices. Neither theory holds up

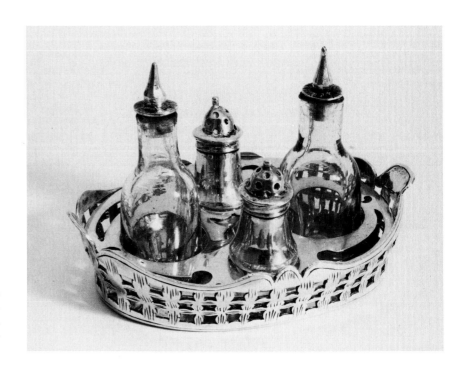

48.
Miniature silver cruet sets are rare. This one, by an unidentified Amsterdam silversmith, bears the date letter *l* for 1768. Dutch, Amsterdam, 1768. Height: 3.2 cm. (1¼ in.). Centraalmuseum, Utrecht

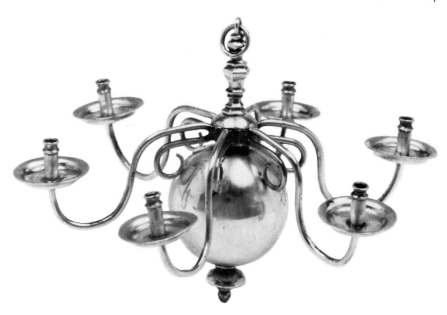

49.
Miniature chandeliers such as this one by the silversmith Arnoldus van Geffen were made for cabinet houses or dollhouses. Dutch, eighteenth century. Diameter: 5.3 cm. (2 1/16 in.). Victoria and Albert Museum, London

very well under closer inspection: standard silver objects were sold almost exclusively to the wealthy, in large cities, and the prospective buyer could easily view full-size silver pieces in town. In those cases when a silversmith might wish to show his wares to buyers in the country, it would have been no great task to transport the objects themselves. The purchaser of such valuable ware as silver, moreover, could scarcely be expected to buy on the basis of a miniature.

The argument for the apprentice as maker of miniatures is equally suspect, since a greater degree of skill might be required to work within the confines of reduced scale than on the actual object. Bungling of a training project, moreover, meant no loss of metal, since the unsuccessful pieces could be melted down for another try.

For a long time it was held that the silversmiths of Leeuwarden in Friesland made silver miniatures as early as the late fifteenth century. Scholarship now places the earliest Dutch work in the mid-seventeenth century, and it is debatable whether the honor of being first in the Low Countries to work in this genre goes to the craftsmen of Leeuwarden or their more prolific counterparts in Amsterdam. Regardless of who was first, within a matter of years, the silversmiths of both of these towns, as well as those of Haarlem, Sneek, Hoorn, Groningen, Harlingen, Bolswer, Franeker and several other locales had turned their attention to this specialty and had begun manufacturing toys. In the eighteenth century, teapots, tea kettles, sugar bowls and creamers, cruet sets (plate 48), coffee urns, baskets and brandy warmers were all added to the list. Table settings and such toy furni-

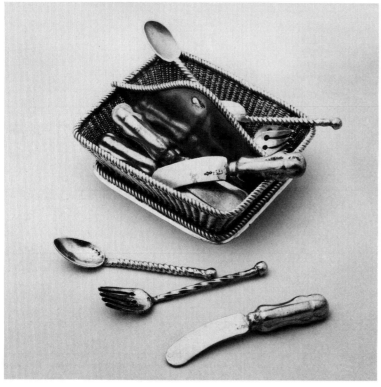

50

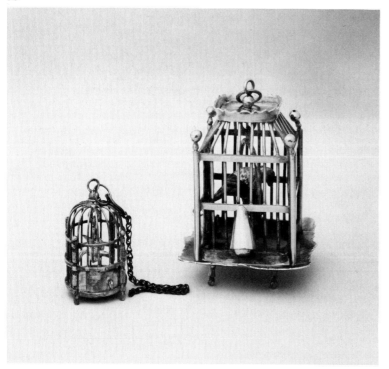

51

50.
This miniature silver basket contains five knives, six forks and six spoons. The basket and the knives, which must have formed the original set, are marked with the Dutch standard mark and the maker's mark *FJT* for Franciscus Treeling, who worked in Sneek and in Amsterdam. Dutch, nineteenth century. Height of basket: 2.6 cm. (1 1/16 in.). Cooper-Hewitt Museum, anonymous gift

51.
Miniature silver birdcages, usually for little silver parrots, have been made in Holland since the nineteenth century. The larger cage has Dutch standard marks on the base and on the door. Dutch, late nineteenth–early twentieth century. Height of larger cage: 8 cm. (3⅛ in.). Cooper-Hewitt Museum, gift of Susan Dwight Bliss

OPPOSITE
52–56.
These silver-filigree toys, which are unmarked, were probably made in southern Germany toward the end of the seventeenth century. In addition to a sled, a spinning wheel, a chandelier, a cradle and a carriage, this assortment includes six chairs, urns, candlesticks, a birdcage, a yarn winder and cabinet. South German, c. 1675-1700. Height of carriage: 4.6 cm. (1⅞ in.). Metropolitan Museum of Art, gift of Mrs. Morris Falman in the name of her late husband, 1931

52

53

54

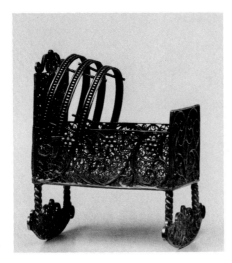

55

56

ture as tables, chairs, fireplaces, birdcages and miniature ships, coaches and horses, windmills and screens were also made.

Many of these miniatures were meant as toys for children of the wealthy, some were intended as display, or cabinet, pieces, and others were made specifically as furnishings for cabinet houses and miniature rooms. It was in the eighteenth century, however, that Dutch production of miniatures reached its peak. So lucrative had the work become that one silversmith, Arnoldus van Geffen, ceased his production of full-size wares to concentrate on miniature articles (plate 49).

Production of these miniatures continued in the Netherlands through the nineteenth and into the twentieth century. Some subjects that were popular with earlier silversmiths, such as baskets (plate 50), birdcages (plate 51) and mousetraps, have never gone out of production. Dutch miniatures are normally hallmarked with the town mark, a date mark, the silversmith's personal mark and, in some instances, a lion rampant and a province mark.

Early German miniature silver is considerably rarer than Dutch— a fact that is somewhat surprising considering the number of silversmiths engaged in making full-scale articles in Germany in the sixteenth and seventeenth centuries. Since the toy centers of Nuremberg and Augsburg supplied the rest of the Continent and England with toys and dollhouses, it would be reasonable to assume that they also turned out miniature silver. A famous set of miniature silver-*filigree* objects of the sort made in Germany in the late seventeenth century does exist in the collection of the Metropolitan Museum of Art (plates 52–56). Among the objects in this collection are a cradle, a chandelier, a birdcage, urns, candlesticks, a group of six matched chairs, a spinning wheel, a cabinet, a bed, a yarn winder, an open carriage and a sled. The pieces are unmarked, but experts think they may have been made at Nuremberg, where a famous military automaton is known to have been fashioned in 1661–65 for the French Dauphin, son of Louis XIV. No less a personage than Jean-Baptiste Colbert, Louis XIV's Minister for Buildings, placed the order for the toy; Sebastian le Presle de Vauban, the French military architect, went to Nuremberg to initiate the project; and the silversmith Johann Jacob Wolrab executed it.

When the piece was completed it was described by Perdon de Subligny: "In Paris, the only subject of conversation is a priceless machine that, we are told, has come from Germany! It is said that, by means of springs, it shows an entire military campaign, lines, trenches, fortifications, an army on parade, and in battle, various actions performed by different soldiers, and the same order and disorder as are to be seen in every fray. Here are soldiers of solid silver—

57.
A pine tree stamped on the base of each of these miniature candlesticks indicates that they were probably made in Germany. Other elements of the marks are indecipherable; German, 1715–40. Height: 5.9 cm. (2⅜ in.). The Henry Francis du Pont Winterthur Museum, Winterthur, Delaware. *Shown actual size.*

one mounted on a restive horse, another on one running or rearing up—holding pistols or sabres in their hands and, it would seem, animated by a human movement. Nowhere is greater pleasure to be found than you have since these fine soldiers have been at court, and everyone there is delighted by their little exercises."

We also know from the accounts of the Royal Treasury that Louis XIV paid: "To Pierre Couturier, known as Montargis, 305 pounds for the days that he was employed watching and regulating the machine of the little army of the Dauphin of the Viennois during the last four months of the year, at the rate of 50 shillings per day."

A pair of miniature candlesticks with stepped hexagonal bases has been identified as coming from Germany in the first half of the eighteenth century (plate 57), and numerous miniatures in collections in the United States, England and Europe, which are simply identified as being of Continental origin, may have been made in Germany, too. The vague dating of these early pieces and the vague attributions derive from the fact that few records have come down to us on the making of these little objects, most of which were intended for cabinets or dollhouses (plate 58).

One of the problems that has plagued silversmiths over the years is that it is possible to melt their work down and turn it into currency,

or fashion it into new, more desirable, or perhaps more stylish, articles. This has happened time and again; frequently the historian has been left with only a few examples with which to document the entire output of a nation's silversmiths during a particular era. In France, for example, because Louis XIV needed money for his military campaigns and for the construction of Versailles, very few samples of what must have been an extraordinary period in the silversmith's art remain (plate 59). Later silver miniatures can be found, however, many of them perfect little copies of the full-scale pieces the silversmiths of the

58.
The maker's mark, *DB* in conjoined ovals, is stamped three times near the base of this miniature teapot and twice on the inside of the lid. European, 1725–90. Height: 12 cm. (4 13/16 in.). The Henry Francis du Pont Winterthur Museum, Winterthur, Delaware

time were designing (plate 60), and some of them reproductions of styles that had been popular a century earlier (plate 61).

The art of making silver toys is thought to have traveled from Holland to England; but the aesthetics of miniature silver in England neglected the majority of Dutch motifs to specialize in utensils (plates 62 and 63), with only a few other objects such as chairs, tables and fireplaces. It is interesting to note that much confusion surrounds the history of miniature silver in England, a country highly regarded for its strict hallmarking system. As scholars have struggled in recent years to shed light on the country's wealth of miniature silver articles, it seems that more names are being removed from the list of those thought to have engaged in this genre than are being added to it. This confusion exists for a variety of reasons.

Some names have been dropped because the only small works the silversmiths are known to have made were thought to have been toy porringers but are now regarded as full-size dram cups—which were small because they were used to serve highly alcoholic beverages. Now that these objects are no longer thought to be toys, or "real" miniatures, the names of John Cole, William Andrews, Jonathan Bradley, William Fleming, Edward Jones, James Goodwin, Joseph

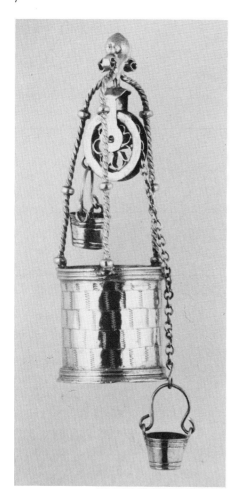

59.
It is uncertain whether a piece such as this miniature bucket and well was made as a toy for a child or as a display piece for an adult. The well bears a Paris hallmark that is impossible to identify; only the initial C is recognizable. French, Paris, probably seventeenth century. Height: 9.3 cm. (3 11/16 in.). Musée de Bellevue, Brussels

60.
This unusually beautiful miniature coffeepot was made by the silversmith Antoine Boullier (active by 1775). French, Paris, c. 1777-78. Height: 9 cm. (3 9/16 in.). The Metropolitan Museum of Art, bequest of Catherine D. Wentworth

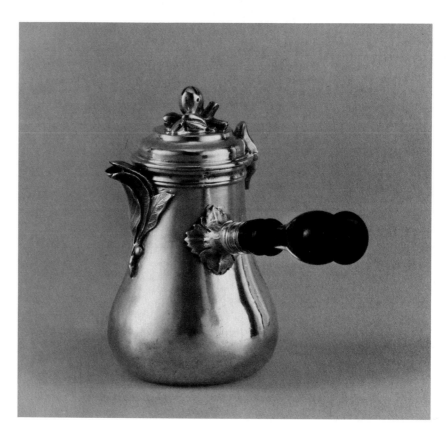

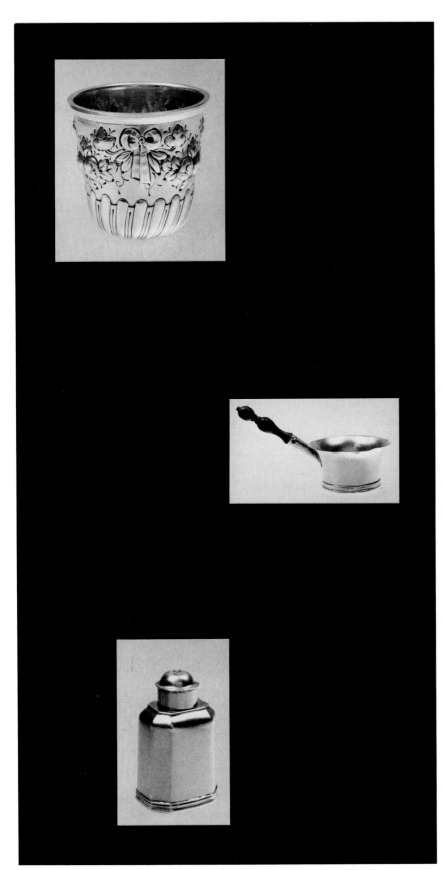

61.
Exquisitely ornamented with a gadrooned base and repoussé garlands of fruit and leaves between bow knots, this miniature silver cup is marked on the bottom with a fleur-de-lis, a crown and the letter *A* with a crown above. French, c. 1800–1900. Height: 4 cm. (1⅝ in.). The Henry Francis du Pont Winterthur Museum, Winterthur, Delaware. *Shown actual size.*

62.
The maker's mark on the base of this miniature silver saucepan reads either *HS* or *IS* in a rectangle with a trefoil below. The piece is also marked with a lion passant. There is no date letter indicating when it was made. English, 1700–1800. Height: 2.2 cm. (⅞ in.). The Henry Francis du Pont Winterthur Museum, Winterthur, Delaware. *Shown actual size.*

63.
Marked on the base with the maker's mark, *DB*, in conjoined circles, this miniature silver tea canister was probably made in England sometime between 1720 and 1800, when tea was a precious commodity that was stored in specially made containers. Probably English, 1720–1800. Height: 3.8 cm. (1½ in.). The Henry Francis du Pont Winterthur Museum, Winterthur, Delaware. *Shown actual size.*

Smith, George Beale and Nathaniel Lock's apprentice Matthew Pickering can probably be removed from the list.

From this early period of English miniaturists, then, we are left with Nathaniel Lock (who had his mark struck in 1697), and a dozen other silversmiths who remain unidentified but whose marks have been found on miniature toys from the period. One of these, TB, is intriguing since a 1630 mark on a wine cup may make him England's earliest miniaturist.

For years the mysterious MA was believed to have been Matthew Madden, William Matthew, Jacob Margas or Isaac Malyn, all of whom used the MA mark between 1697 and 1710. All of the four craftsmen mentioned were entered on Guild rolls as "large-workers" in the eighteenth century. It is now thought that most of the work marked MA is by George Manjoy, and if this is so he may have been London's first specialist in miniatures.

64.
A group of miniature silver articles from England, including a saucepan, candle snuffer, plate warmer, coffeepot and porringer, and ranging in date from 1670 (the porringer) to 1720 (the saucepan and coffeepot). The saucepan bears the mark of the prolific English miniaturist David Clayton. Height of plate rack: 6.8 cm. (2 11/16 in.). Museum of Fine Arts, Boston, purchase from the Theodora Wilbour Fund Number 2 in memory of Charlotte Beebe Wilbour. The snuffers are the gift of Edgar M. Bingham.

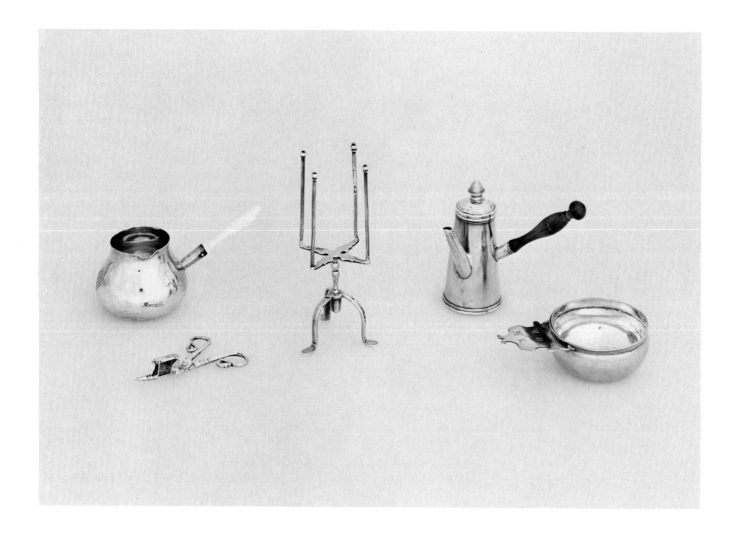

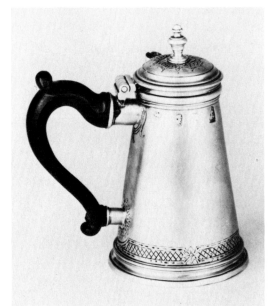

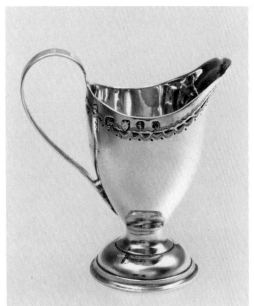

65

66

65.
This coffeepot is held to be the only marked piece of miniature silver by Paul de Lamerie (1688–1751), one of England's great silversmiths of the eighteenth century. The pot is fully marked, with the date letter *N* for the year 1728–29 and Paul de Lamerie's first mark: *LA*. English, 1728–29. Height: 7.8 cm. (3⅛ in.). Folger's Silver Collection, Procter & Gamble Company

66.
The marks that can be seen under the engraved border of swags near the rim of this miniature creamer include the date letter for the year 1784–85, the lion passant, a leopard's head crowned and the monarch's head. The maker's mark, which is only partially visible, may be that of William Simmons. English, London, 1784–85. Height: 4.8 cm. (1 15/16 in.). The Henry Francis du Pont Winterthur Museum, Winterthur, Delaware

English miniature silver divides into two distinct periods: the first runs from 1684 to 1715; the second, from 1720 to 1740. In both periods a silversmith named David Clayton was active, and all experts now agree that many pieces previously ascribed to Augustin Courtauld and John Clifton were actually made by Clayton but erroneously ascribed for two reasons—first because of confusion between the marks *ac* and *dc* in Gothic characters, and second because Clayton's 1697 mark, *CL*, was attributed to John Clifton. Now that this matter has been settled, it is apparent that David Clayton was one of England's most prolific miniaturists (plate 64).

Almost all early literature on silver miniatures cites John Le Sage as the maker of some of the rarest, most skillfully crafted miniatures in existence. Le Sage became a master in 1718 and set up his shop in Little St. Martin's Lane—that is known. But the question of whether or not he is responsible for such highly praised little creations as a chocolate pot complete with its stirring rod, a frying pan, a coffeepot and other elegant works is a question that, at least for now, remains.

With all of this confusion, it is difficult to know, when one finds a piece such as the Folger collection coffeepot that bears the mark of one of England's most prestigious eighteenth-century silversmiths—Paul de Lamerie—whether or not the pot could actually have been made by him (plate 65).

Illegible marks frequently make it difficult to say with certainty who the maker was (plate 66); the collector must beware of eager

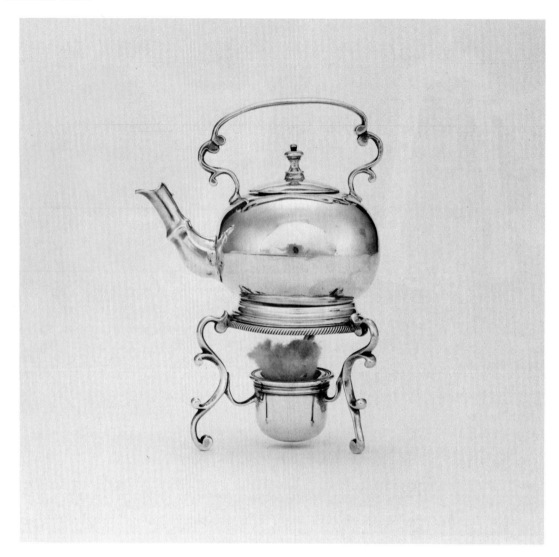

67.
The maker's mark *IS* with a pellet above
appears on this miniature silver teakettle
on a warming stand. English, c. 1730.
Height: 9.37 cm. (3 ¾ in.). Museum of Fine
Arts, Boston, the Theodora Wilbour Fund
Number 2 in memory of Charlotte Beebe
Wilbour. *Shown actual size.*

dealers who are anxious to ascribe a piece to an important silversmith when no evidence exists in Guild records that that person ever worked in miniature. It is unfortunate that the makers of so many exquisite pieces of English silver remain, and may forever remain, unknown to us (plate 67).

By 1750 the making of silver miniatures had virtually ceased, to be revived briefly in the Victorian period. Only a few pieces were made during the queen's reign, although a display was part of the Great Exhibition of 1851 at the Crystal Palace. With increased industrialization, copies of pieces from the great age were turned out with varying degrees of care, many of them cast rather than wrought, to meet the demands of dollhouse enthusiasts. Tea and coffee sets were particularly popular with collectors in the nineteenth and early twentieth centuries, and such provincial cities as Chester (see colorplate 17), Birmingham (plate 69) and Sheffield—all centers of manufacture for numerous small silver articles—produced some charming sets for the market.

In America, colonial silversmiths kept pace with their colleagues in England and skillful artisans produced a limited number of miniatures, most of which were made toward the end of the seventeenth century by unknown American and English workers who did not

68.
The cup on the left, which is unmarked, is held to be by the fine Boston silversmith John Coney. That on the right bears the mark of Paul Revere I, the father of this country's great silversmith and patriot Paul Revere. American, Boston, c. 1690 and 1720, respectively. Height: 3.1 cm. (1¼ in.) and 3.3 cm. (1 5/16 in.). Museum of Fine Arts, Boston, bequest of Mrs. F. Gordon Patterson. *Shown actual size.*

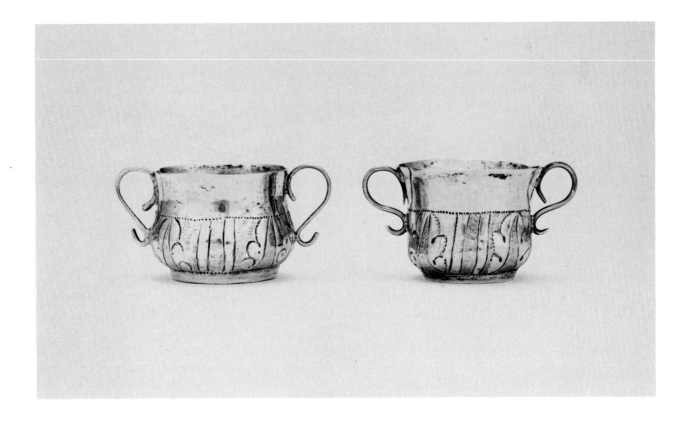

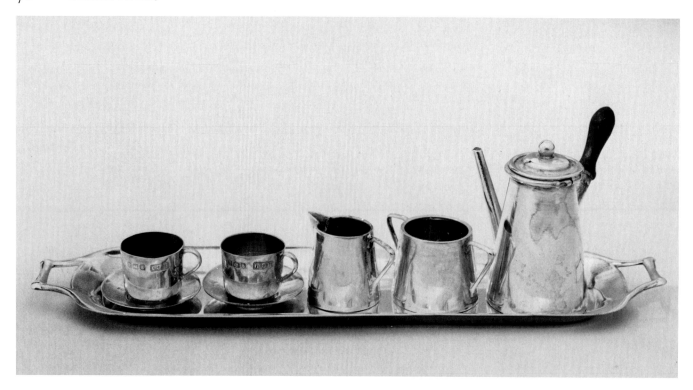

69.
Five of the pieces of this miniature silver coffee set are fully marked, but the two saucers bear only the standard marks and the maker's mark, *HCD*. English, Birmingham, 1905. Height of coffeepot: 3.8 cm. (1½ in.). Cooper-Hewitt Museum, gift of Mrs. John Innes Kane

mark their work. Not all early American silver miniatures were unmarked, however. The Boston Museum of Fine Arts has two caudle cups: one bears the mark *PR* in a rectangle for Paul Revere I (1702–1754), the father of Paul Revere the silversmith and patriot; the second is believed to be by John Coney of Boston, who worked at the end of the seventeenth and in the early decades of the eighteenth century (plate 68). Other American silversmiths known to have worked in miniature include Peter Oliver, John Edwards, Samuel Edwards and Ebenezer Moulton, all of Boston, and Elias Pelletreau of New York.

Silver miniatures have been particularly popular with the American collector and dollhouse owner, and production continues in the United States to the present day. Many of the articles made by the twentieth-century silversmith are copies of forms that were popular a century or two ago (plates 70 and 71). The quality of these pieces is frequently high; in some cases more care has been lavished on them than the earlier miniature articles received. As long as the collector recognizes them for what they are, there is no reason to exclude them from a collection.

70.
In the late nineteenth and early twentieth centuries European silversmiths made small silver toys modeled after those of seventeenth- and eighteenth-century silversmiths. This miniature sulky is marked *E. Hansen 830S*. European, c. early twentieth century. Length: 8.5 cm. (3 7/16 in.). Cooper-Hewitt Museum, anonymous gift. *Shown actual size.*

71.
Arthur Stone (1847–1938), an American silversmith, made these miniatures: a caudle cup, a tankard, a toast rack, a tea caddy and a chair. American, Gardner, Massachusetts, early twentieth century. Height of tankard, including finial: 5.5 cm. (2⅛ in.). Museum of Fine Arts, Boston, gift of Miss Alma Bent

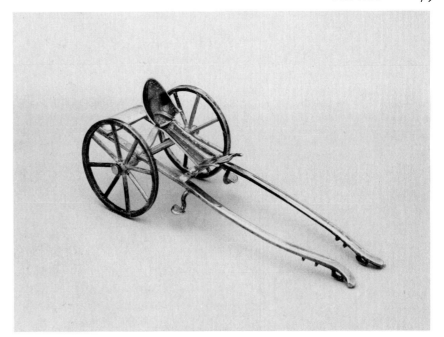

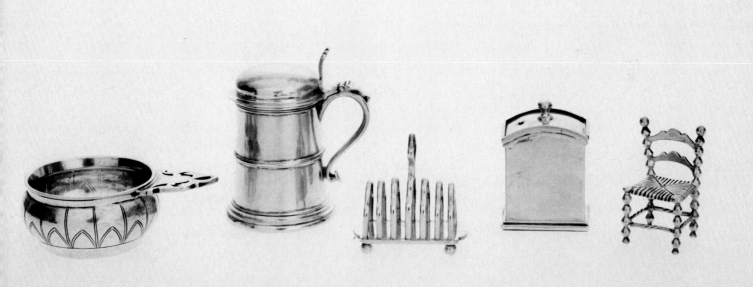

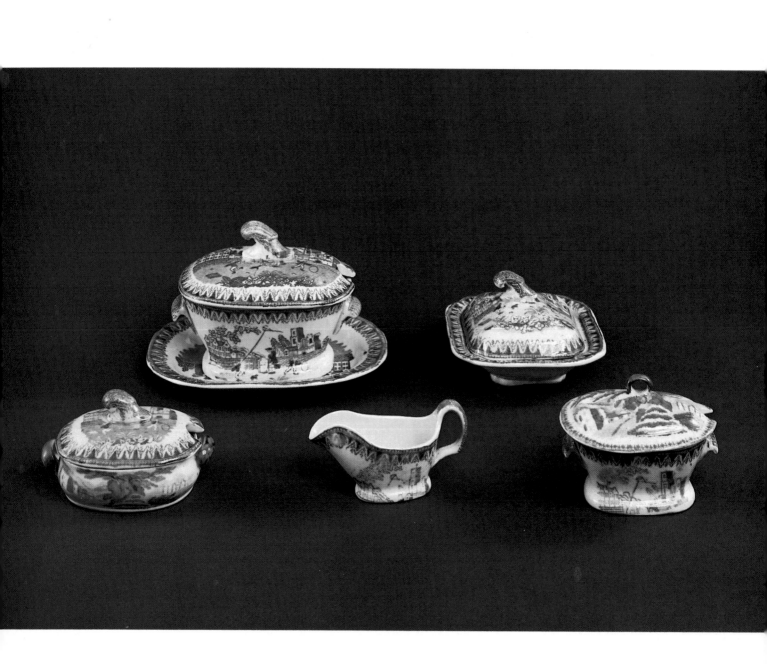

5 Pottery, Porcelain and Glass

The manufacture of pottery, porcelain and glass objects in miniature, like that of miniature silver, developed early and may, in fact, be nearly as old as the crafts themselves. There is little difference between the way a miniature blown or molded glass vase is made and the manufacture of a full-size one; nor are the techniques necessarily different for making miniature clay pots and large ones. These early miniatures are considered antiquities, however, rather than antiques, and when they are found or offered for sale, they are more likely to end up in museum collections than in private hands. It was in Europe in the sixteenth century that craftsmen regularly began to make miniature pottery and glass to be used to furnish dollhouses and miniature rooms or to be displayed singly or in groupings along with their owner's objets d'art and other valuable possessions. These miniature creations, and the production of the several centuries that followed, are those most likely to be collected today.

Miniature ceramics and glasswares can be found in three sizes: small, made for display in dollhouses or miniature rooms; medium, commonly referred to as "sample" size, although it is unlikely that this was the reason for their manufacture; and large, made for children's use. Quality pieces can be found in all three sizes, and it is this criterion that should guide the collector.

Pottery and Porcelain The fashioning of miniature ceramics for dollhouses began early in Germany. In Nuremberg, tableware and kitchen utensils decorated with brilliantly colored fruit, flowers and birds were being produced by the middle 1500s. The 1639 Nuremberg Baby House has a fine complement of crockery in its larder (see colorplate 3), as do other houses from this time. Mugs, bowls, jugs and

Colorplate 18.
These five miniature serving pieces are from a blue-and-white bat-printed earthenware dinner service made in Staffordshire, an important center for porcelain and pottery manufacturing. English, Staffordshire, nineteenth century. Height of tureen: 8.1 cm. (3¼ in.). Museum of Fine Arts, Boston, gift of Mrs. Ralph Lowell "in memory of Mrs. Thatcher Loring (Margaret Fuller Channing) from her granddaughter, Mrs. Ralph Lowell"

basins can all be seen lining the cupboards and shelves of these kitchens and storerooms, small renditions of their full-size counterparts.

In Holland, where cabinets and dollhouses were popular as early as the seventeenth century, several kinds of pottery and *porcelain* were available for the collector. Miniature Dutch earthenware vessels and bowls can be seen in the kitchens and workrooms of dollhouses, while Chinese ceramics, and in the following century Japanese, formed a prominent part of the collections in the little *porseleinkamer*, with its miniature china closets (colorplate 19).

Of all the riches unloaded at Dutch harbors during the seventeenth century—and they included such luxuries as exotic spices, Bengal sugar, silks, ivories, lacquerwork and camphorwood trunks—most popular with the country's burghers was the porcelain that arrived from the Orient. Table services, jars and sets of mantel vases were eagerly purchased and displayed in the china cabinets and collectors' cabinets of the day. In fact, the eagerness with which the Dutch acquired porcelain from the Orient, both in miniature and in full size, can hardly be exaggerated. From the arrival of the first cargoes of Chinese porcelain, which the Dutch called *kraakporselein* after the *caraques*, the Portuguese sailing vessels that brought these exotic luxury items from the Orient in the sixteenth century, it would seem that no Netherlander could acquire enough *blue-and-white* porcelain. By the mid-1650s, in an attempt to compete with the popularity of these imports, the Dutch factories at Delft abandoned their production of colorful *maiolica* to produce *tin-glazed earthenwares* unabashedly painted with blue-and-white *chinoiseries* or floral patterns in imitation of those found on the more expensive porcelain from the Orient. These, too, were proudly displayed, both in full size and in miniature.

In 1699, when the British ship *Macclesfield* arrived in the port of Canton, a new era began. By mid-century the kilns of Ching-te-chen were supplying European boats in Canton harbor with porcelain pieces whose shape and decoration were influenced by European pottery. Known as *Chinese export porcelain*, these wares, in both miniature and full size, were manufactured to satisfy Western customers.

After the American Revolution had severed the colonists' connections with the British market, the Chinese produced export wares to satisfy the American taste as well. Decorative motifs such as the American eagle, American ships and historic buildings (Mount Vernon, various state capitols, etc.) were quickly adopted. The Henry Francis du Pont Museum in Winterthur, Delaware, has a pair of miniature bowls decorated with a scene showing the founding fathers seated around a table, drafting the Declaration of Independence. Another miniature in the Winterthur collection is a late-

Colorplate 19.
Oriental blue-and-white porcelain, both full-size and miniature, was very popular with collectors in Holland in the seventeenth century. The fine collection in the Sara Ploos van Amstel Dollhouse is grandly displayed in the porcelain chamber, or *porseleinkamer*. Dutch, Amsterdam, 1743. Height of room: 49 cm. (19⅛ in.). Gemeentemuseum, The Hague

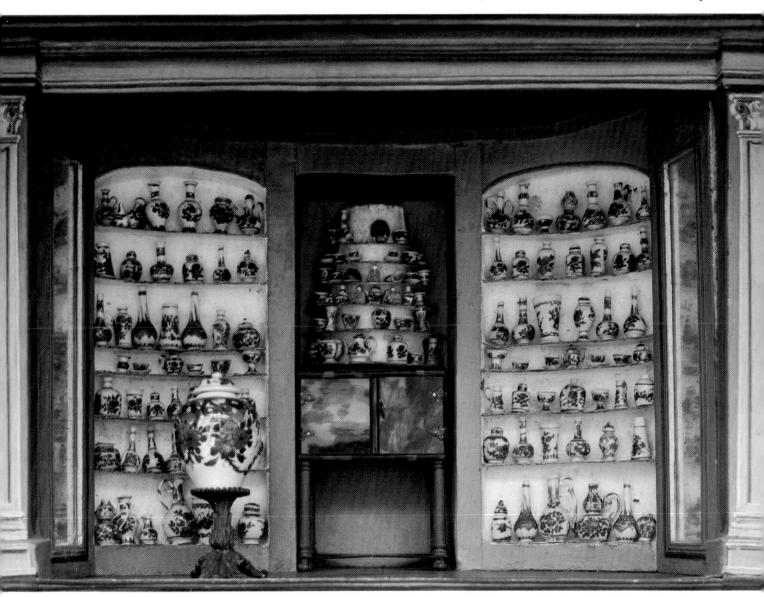

eighteenth-century cup and saucer decorated with a woman's bonneted head and a border of gold stars on a blue background. There is also a miniature tea set dating from the decade 1775–85 that includes tea- and coffee cups and a sugar bowl and creamer with twisted handles and flower finials—decidedly Western features. The abundance of Chinese export miniature ware in both museums and private collections testifies to the quantity produced, and many contemporary letters to and from travelers include requests for purchases of toy china to be shipped or carried back to America as gifts for children.

At one point or another, from the seventeenth through the nineteenth centuries, virtually all the English potteries made miniature versions of their wares, again primarily as toys for children. From 1758 to about 1840 English artisans turned out numerous pieces of creamware; outstanding among these were dishes with pierced openwork designs and sets of plates, cups and saucers with painted decoration. Later, Oriental patterns, including the famous Willow pattern, were applied by *transfer printing*—the process by which a design or picture was first engraved on a copper plate, then transferred to thin paper and thence to the glaze. Although much of this early creamware is identified as Leeds, and often evidence points in that direction, it is noteworthy that in all the considerable mass of catalogues and other advertising material printed over the centuries on Leeds ware, apparently no mention was made of toys or miniatures.

By the 1760s, Josiah Wedgwood (1730–1795) had perfected his lightweight creamware, with its subtle, brilliant glaze, a line that overnight became one of the most successful of English productions. Many of the regular items of Wedgwood's catalogue were also done in miniature, and later catalogues continue to list small wares measuring from 2 inches up. A few miniature cream jugs measuring about 2½ inches, manufactured in about 1750, are to be found in private collections, where they are treasured as great rarities. Another rarity, made about 1790, is a tiny flower basket 4 inches long, made in the caneware pattern and decorated with red leaves in relief. There is documentation dating from 1795 of an order issued by Queen Charlotte—the wife of George III—for "2 toy tea sets," and the Wedgwood Museum in Barlaston, England, has part of a dinner set of plain Wedgwood creamware that is supposed to have belonged to the Darwin children (a believable story, since Charles Darwin's mother, Susannah, was the daughter of Josiah Wedgwood).

The Wedgwood miniature dishes of which most examples remain extant are *jasperware* (plate 72), with powder blue, light green or later dark blue grounds—and Queen's Ware (named after Queen

72.
The vignettes on this jasperware potpourri basket are fine examples of the kind of Neoclassical designs in vogue in the late eighteenth century. On one side Cupid receives a bow lesson; the other (not shown) shows a market with cupids for sale. English, c. 1790. Height: 7.5 cm. (2½ in.). Private collection

Charlotte). In jasperware, the ground is adorned with traditional designs in white relief. These designs usually depicted themes from Classical mythology as rendered by John Flaxman (1755–1826), a leading proponent of the Neoclassical style in England, who also served from 1787 to 1794 as director of the Wedgwood studio in Rome. Miniature teapots, cream jugs, sugar boxes, cups and saucers were all made in the eighteenth century and, because of their popularity with collectors, have remained in production up to the present. The differences between eighteenth-century and later pieces can be slight and nearly impossible for even an experienced collector to detect unless examples from the two centuries are placed side by side and scrutinized. These jasperware miniatures are of enduring interest because of the extraordinarily fine detail lavished by the artists on the tiny pieces, no less dedicated a performance than that found in the full-size pieces.

In the 1760s, Lowestoft potters made miniature tea sets with painted decoration. One such tea set has a pattern of a Chinese river scene painted on it in underglaze blue; another, about 1770–80, shows a Chinese garden scene. The Spode factory also produced pottery dinner sets and tea sets in miniature. The decoration on the tea sets, six of which were displayed at the Spode Bicentenary Exhibition in London in 1970, varies from polychrome floral decoration on a pale blue ground to drabware decorated only with bands of *gilding*.

During the nineteenth century Staffordshire potters contributed a wide variety of tea sets and earthenware dinner sets to the miniature repertory (see colorplate 18 and plate 73). Dinner sets with fifty or more pieces exist in the Willow pattern, and private collections abound with specimens from a long list of Victorian potteries, notably a set

from about 1860 by C. Meigh and Sons, of which, miraculously, nearly one hundred pieces have survived. Included in the set are one large tureen, lid and stand; four small tureens, lids and stands; four vegetable dishes and lids; eleven rectangular dishes in four sizes; twelve soup plates; twenty-four dinner plates; twelve pudding plates; twelve side plates; four ladles and two sauce boats. Through the years a rectangular plate and an extra ladle may have disappeared, although no record exists indicating that they were actually purchased as part of the original set.

Porcelain was not manufactured in England until the middle of the eighteenth century, and although data abounds on the full-size pieces, little information was recorded about the miniature or "toy" sets. Most of the prominent English producers of porcelain turned out miniature versions of their stock, including individual pieces and sets from Bow, Caughley (plate 74), Chelsea, Liverpool, Lowestoft, Minton, Rockingham, Swansea and Worcester (plate 75).

Porcelains from Coalport, usually known as *Coalbrookdale* porcelain, began to appear early in the last century. Many pieces are marked, typical marks being *C.C.*, *C. Dale*, *Coalport* and *Coalbrookdale*, although the bulk remained unmarked and, as a result, many nineteenth-century pieces have been erroneously attributed to the factory. Derby porcelain was made from the middle of the eighteenth

73.
There are forty-eight pieces in this miniature dinner service. The white ground of the earthenware set is decorated with a transfer-printed pattern in pink-red. It includes a central landscape design of Oriental inspiration with a garden house at the left, a small sailboat being poled along a river or bay at the right, and various buildings in the background. English, Staffordshire, c. 1830–60. Height of tureen: 10.3 cm. (4⅛ in.). The Henry Francis du Pont Winterthur Museum, Winterthur, Delaware

74.
This porcelain teapot is part of a miniature tea set made at the Caughley factory in Shropshire. The white ground is decorated in blue with a landscape with small buildings and a flock of birds, and on the dome of the cover, two boats with sails. English, 1780–90. Height: 7.8 cm. (3⅛ in.). The Henry Francis du Pont Winterthur Museum, Winterthur, Delaware. *Shown actual size.*

century, and the firm is still in existence today. In 1890 Derby was named "manufacturers of porcelain to Her Majesty, Queen Victoria," and their product became famous as Royal Crown Derby. They made miniatures, many of the sets being decorated with Japanese-style patterns. Spode, along with Coalbrookdale, became among the most abundant of miniature porcelain makers. Besides tea sets, Spode production in miniature includes baskets, vases, basins and ewers decorated with gold and painted fruit and floral designs.

In the nineteenth century, porcelain manufacturers on the Continent succeeded in cutting in on what had been virtually an English monopoly on the miniature market. Limoges and the Paris factories, Meissen in Dresden (plate 76) and Nymphenburg in Munich, Popov near Moscow (plate 77) and countless other factories from Scandinavia to Austria (colorplate 20) to Italy enlivened their production with miniature versions of their wares.

In America, potters had begun to produce miniature stoneware, some of them as early as 1800, and the industry flourished through the nineteenth century. During the early 1820s, the Crolius family of New York was making stoneware pitchers from ½ to 1½ inches in height. Dishes, jugs and crocks were typical forms, some of them with inscriptions, even some with advertising. Many of these pieces are in salt-glaze gray with cobalt-blue painted decoration.

From 1833 until the end of the century, miniature Shenandoah

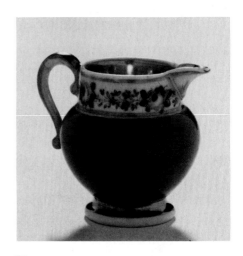

75.
A beautiful miniature porcelain jug with a green body and white collar with floral decoration. It is banded at the top and bottom with gilt. The signature on the base reads: *Chamberlains/Wor*. English, Worcester, c. 1808–20. Height: 4.6 cm. (1⅞ in.). The Henry Francis du Pont Winterthur Museum, Winterthur, Delaware. *Shown actual size.*

76.
In the mid-nineteenth century, during a brief revival of the rococo style, the Meissen factory produced objets d'art and tableware decorated with soft colors and pastoral scenes. The scenes of shepherdesses set in cartouches that surround this cup were hand-painted by the artist Helene Wolfsohn in 1860. The forms themselves were made of hard-paste porcelain, a delicate and trans-lucent type first developed in Europe by the Meissen factory, to imitate the greatly ad-mired Chinese porcelain. German, 1860. Height of cup: 3.7 cm. (1½ in.). Private collection

77.
The Popov factory, an early private porce-lain factory in Russia, was established in 1765. Gilding and bold colors, such as the deep ruby red of this miniature coffee and tea set, characterize the factory's production after the Napoleonic Wars, when designs in the Empire style, similar to those pro-duced by the French at Sèvres, were much admired by wealthy Russians. Russian, mid-nineteenth century. Height of teapot: 5 cm. (2 in.). Private collection

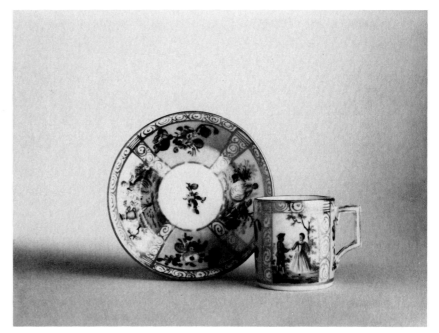

76

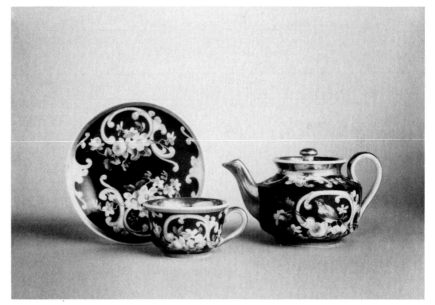

77

Colorplate 20.
Richly ornamented with gold overglaze decoration, this miniature porcelain tea set bears a mark indicating that it was made in Austria between 1830 and 1860, although the manufactory is not known. Austrian, 1830–60. Height of teapot: 6.8 cm. (2¾ in.). Cooper-Hewitt Museum

pottery was made in Strasburg, Virginia. This production is streaked or mottled in striking shades of red, green and manganese. The most frequent forms at potteries in Shenandoah, as well as in Pennsylvania, New England and the Midwest were cups, saucers, jugs and teapots, but tiny flowerpots are also found. Starting in the 1820s, Bennington, Vermont, became a center for the manufacture of miniature ceramics, and many rare pieces are preserved in the Bennington Museum. In an

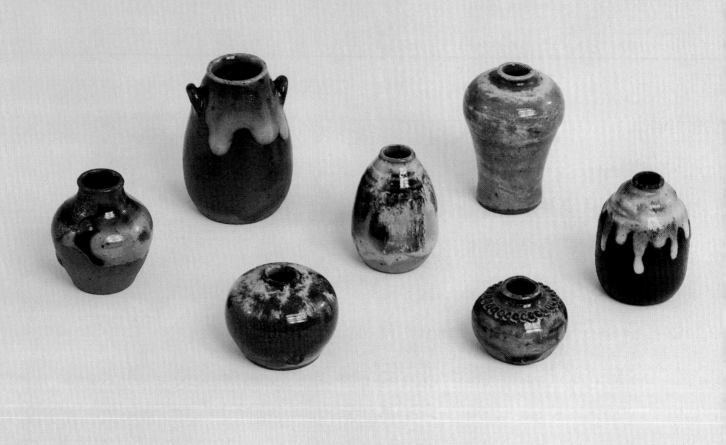

Colorplate 21.
These seven miniature earthenware vases by the French potter Auguste Delaherche (1857–1940) are modeled after traditional Japanese vessels and reflect the influence Japanese work has had on Western potters in the twentieth century. French, made after 1904. Height of tallest vase: 4.5 cm. (1¾ in.). Museum of Fine Arts, Boston, gift in the name of Robert H. Monks. *Shown actual size.*

endeavor to lay to rest once and for all the notion that these miniatures were salesmen's samples, it should be noted that records exist proving that an itinerant peddler, engaged to sell Bennington pottery to rural farm families until about 1825, carried full-size crockery, not miniatures, with him on his rounds.

At the end of the nineteenth century, the influence of imported Oriental pottery, and the desire to reproduce it, led to experimentation with traditional materials and techniques in potters' studios (colorplate 21) as well as in factories. In the twentieth century, the production of miniature pottery and porcelain has continued, although most pieces of quality have been made by the lone craftsman.

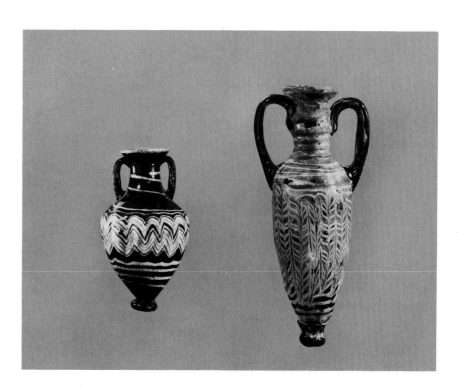

78.
These tiny glass amphorae were made by fusing pieces of colored glass onto a baked clay core. The shape, which is the same as that of the large amphorae used to store oil and wine, is ideal for keeping a small amount of precious oil protected from the elements. Eastern Mediterranean, sixth to fourth century B.C. Height of tallest amphora: 14 cm. (5½ in.). Toledo (Ohio) Museum of Art

Glass Archaeological finds in Egypt and Greece show that miniature glass objects have been popular since antiquity (plate 78). During the Middle Ages glassblowers in Italy, Germany and Holland often made tiny "friggers" (small glass objects fashioned at the end of the day from leftover glass), as indeed glassblowers have continued to do over the centuries in Venice and at other centers where visits to glass factories have been a regular part of tourist itineraries (see plates 84 and 85). The itinerant lampworker, with his bundles of colored glass rods and canes and portable furnace, was long a feature of country fairs. In 1831 an English girl named Emily Shore described in her

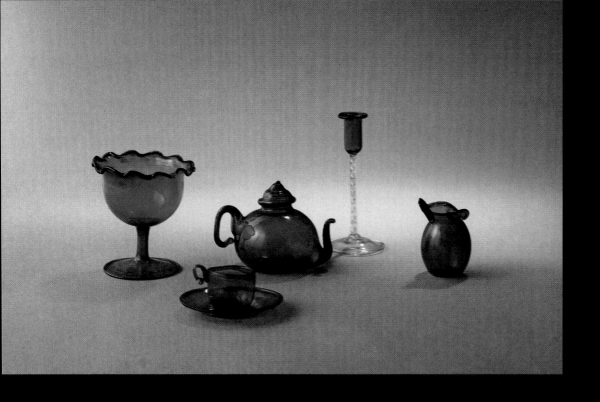

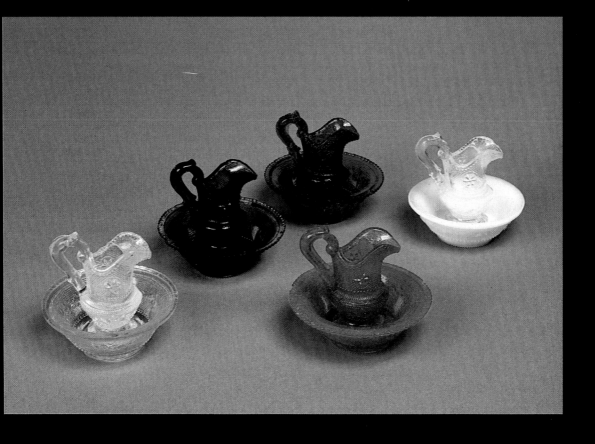

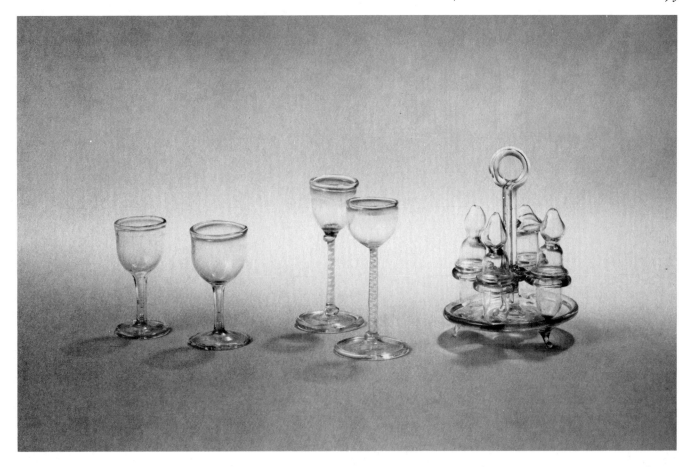

79.
Made of clear blown glass, this miniature cruet set and two pairs of wineglasses were made in Bristol, England, in the mid-nineteenth century. Height of wineglass with ribbon-twist stem: 3.5 cm. (1⅜ in.). Cooper-Hewitt Museum, gift of Hammill and Barker

OPPOSITE TOP
Colorplate 22.
Made in Bristol, this miniature blown-glass tea set includes a compote, cup and saucer, teapot, wineglass and cream pitcher or milk jug. English, Bristol, mid-nineteenth century. Height of wineglass: 4.5 cm. (1¾ in.). Cooper-Hewitt Museum

OPPOSITE BOTTOM
Colorplate 23.
These miniature washstand sets, in a variety of colors, were probably made by the Boston & Sandwich Glass Company of Sandwich, Cape Cod, Massachusetts, sometime between 1835 and 1850. Height of pitcher: 6.2 cm. (2½ in.). Corning Museum of Glass, Corning, New York

diary the joy of watching a lampworker performing in Bedfordshire: "He made glass baskets, candlesticks, birds and horses. He sat at a table, and before him was a little furnace which contained a flame of intense heat, though it was only kept by a tallow. . . . We bought a few minor things, and there was an elegant and beautiful ship."

Ships, birds, flowers, tiny figures, bottles, vials, baskets—all have continued to be made by glassblowers over the centuries. In the music room of the Sara Ploos van Amstel Baby House (see plate 7) are tiny seventeenth-century rummers, goblets and beer glasses of both green and colorless glass (some with blue stems) and, in the wine cooler, bottles of a coarser green glass. Already in the eighteenth century there was a highly developed school of glassmaking in Nevers, southeast of Orléans, where delicate and highly colored table decorations were being made of blown and pincer-drawn glass, along with crèche figures and scenes. By that same time Bavarian and Bohemian glassblowers had started to make hand-blown toys in the Venetian tradition. In England, by 1760, John Bench was making glass miniatures in Warwick, and a glassblower's catalogue for 1771 lists "toys for young ladies" as part of his stock.

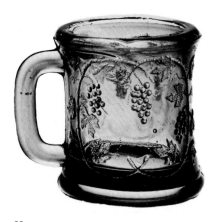

80.
The King, Son & Company, or Cascade Glass Company, made this bluish-violet pressed-glass mug. American, Pittsburgh, c. 1875. Height: 5 cm. (2 in.). Corning Museum of Glass, Corning, New York. *Shown actual size*.

Muson King of Manchester was advertising "all sorts of glass toys in miniature" in 1785, documentary evidence of a market well before 1800. By the turn of the century the center of the industry had gravitated to Birmingham, where ten glass toymakers were listed in the tradesman's directory in 1816, a number that had grown to thirty-two by 1855. The Nailsea Glass Works had opened a branch in Birmingham by 1824. Bristol, too, was active in the production of glass miniatures, producing fine objects in both colored (colorplate 22) and clear glass (plate 79).

Interesting vases and pitchers of swirled striped glass in blue and white, pink and white and green and white were made at the Saint-Louis glass factory in the Munzthal, Lorraine, in the 1840s, together with miniature paperweights, which are very rare, and bowls and ewers measuring from two to four inches.

Early attempts to establish glass factories in the colonies failed, and it was not until the 1780s that Americans could purchase glass table-wares made in this country. In 1825, what is regarded as the greatest development in the history of glass since the Romans had learned glassblowing in about 50 B.C. occurred when the mechanical press was invented. With this new machine, two men of no great skill could produce four times as much glass in a day as a team of several hundred expert glass blowers. For the first time in history glass tablewares became available to the middle classes. The growing prosperity of this class at this time also permitted them to indulge their children with more luxuries. Manufacturers, quick to sense this new market, soon began listing miniature glassware in their catalogues. These new "toys" were incredibly popular, and in 1876, Doyle & Company of Pittsburgh proudly announced that it had sold 20,000 sets of glass toys, with 12,000 toy cups and saucers being sent to Springfield, Vermont, alone. From Pennsylvania (plate 80), which had both good river transportation and an abundant coal supply, the industry spread to Ohio, West Virginia, New England (plate 81) and the Midwest (plate 82). The manufacturer—or at least the geographical locale—can be identified for most of these pieces, although copying pressed glass designs was simple and relatively common, and it is often impossible to say for certain where a particular piece was made (plate 83).

One of the best known of the pressed glass manufacturers was the Boston & Sandwich Glass Company, of Sandwich, Massachusetts. A specialty of the firm was a series of miniature glass oil lamps in all the types of glass popular during the nineteenth century: clear, colored, milk, satin and spangled. These and later miniature lamps were produced in quantity, but because of their great popularity with collec-

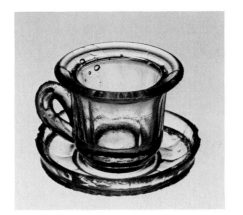

81.
Made of pressed, colorless glass, this cup and saucer is similar to other miniatures made in New England in the nineteenth century, but bears no marks or signatures indicating the name of the manufacturer. American, New England, c. 1840–70. Diameter of saucer: 4.5 cm. (1⅞ in.). Corning Museum of Glass, Corning, New York.

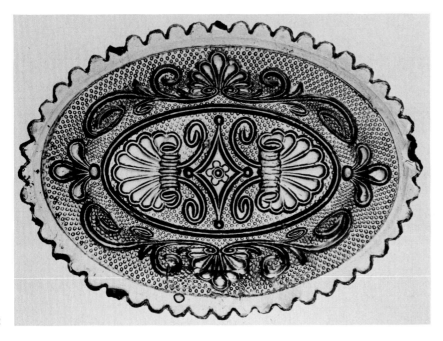

82

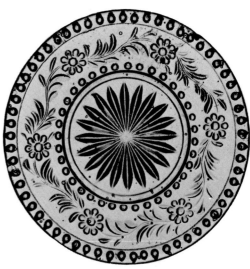

83

tors they are increasingly hard to come by. The company also turned out a variety of other objects in miniature, including pitchers and basins (colorplate 23), in a selection of colors and types of glass.

At the Paris International Exhibition of 1878 one of the striking attractions was the newly developed glass of Emile Gallé (1846–1904) of Nancy, who had worked out a technique using deeply colored glass in heavy masses, often multilayered and etched or wheelcut to render natural motifs. His innovations were a trail-blazing step in the development of Art Nouveau. Together with his regular-size vases, Gallé produced a quantity of miniatures. Both the large and small versions were marked with either etched or molded marks—*Cristallerie d'Emile Gallé, Emile Gallé, E. Gallé* and other variations—some of which include the date of manufacture.

82.
In the nineteenth century numerous Midwestern glassworks, many of them located in Ohio, produced miniature versions of their larger wares. This oval bowl is of pressed, colorless glass. American, the Midwest, c. 1835–50. Length: 8 cm. (3¼ in.). Corning Museum of Glass, Corning, New York

83.
The bold pattern of this clear glass miniature plate was made by pressing the glass into a mold. American, c. 1900. Diameter: 6.6 cm. (2⅝ in.). Corning Museum of Glass, Corning, New York. *Shown actual size.*

84.
Patterned glass was popular with Venetian glassmakers. This unusual miniature mug, with a handle in the form of a salamander (the animal long thought to be able to survive fire), was probably made as a "frigger" from leftover glass in the glass-blower's studio. Italian, Venice, nineteenth century. Height: 4 cm. (1 9/16 in.). Corning Museum of Glass, Corning, New York

85.
In Venice, the tradition of making miniature glass objects is an old one. This miniature wineglass displays a number of hallmarks of Venetian glass, including the use of different kinds or colors of glass (here, clear and white), the swirled ribbon pattern of the glass and the winged stem. Italian, Venice, second half of nineteenth century. Height: 6.8 cm. (2 ¾ in.). Corning Museum of Glass, Corning, New York. *Shown actual size.*

After the master's death in 1904, the factory continued producing Gallé products until 1913. Another glassworks that was influenced by Gallé was that of Antonin and Auguste Daum, two brothers who took over their father's business in Nancy and who made cabinet or display pieces in small as well as large sizes. Daum vases are marked *Daum, Nancy.*

From 1894 to 1920, Louis Comfort Tiffany (1812–1902) manu-factured his famous and familiar glass, popularly known as *favrile* glass. He had been deeply influenced by the revolutionary works of Gallé and by his own interest in the shapes and colors of ancient glass objects, including miniatures found by archaeologists in the Middle East. Tiffany used a broad spectrum of colors ranging from clear glass to opaque black, with literally thousands of nuances of blue, green, gold and red blended in the unique iridescent combinations for which he became famous.

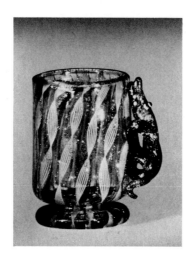

84

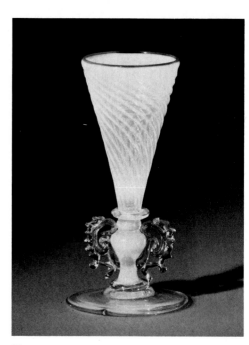

85

Tiffany's output in the miniature field closely parallels his full-size versions (plate 86). The miniature vases are of all shapes and styles, including even radically new irregular forms. They range in size from 1¼ to 4¼ inches and were intended for cabinets or display.

Tiffany, of course, soon had many imitators. Two former workers at the Tiffany plant set up their own company, the Quezal Art Glass and Decorating Company, in 1902 in Brooklyn, New York (plates 87 and 88). Another worker, Victor Durand, left Tiffany to join forces with the Vineland Glass Works at Vineland, New Jersey, where he manufactured an imitation Tiffany glass called Durand Art Glass. Frederick Carder, English by birth, was hired by Steuben Glass Works in Corning, New York, to manufacture a line of iridescent glass called Aurene and *verre de soie*. The company is still in existence and maintains a collection of antique and modern glass in its museum, the Corning Museum of Glass.

86.
"Favrile glass," created by Tiffany and his chemist, Dr. Parker McIlhenny, was tremendously popular. This vase of favrile glass changes color from a rich, iridescent green to gold swirls to smoky cream at top. The vase is marked on its bottom with "L. C. Tiffany Favrile 1377C." American, New York, about 1908. Height: 9.5 cm. (3¾ in.). Chrysler Museum at Norfolk, Virginia

87 and 88.
Quezal Art Glass and Decorating Company, a glass manufactory founded by two ex-Tiffany glassmakers, specialized in producing opalescent and iridescent art glass. Most of their forms, like the two blown glass vases shown here, were simple rounded or fluted shapes, usually based on natural forms. Brooklyn, New York, 1902–20. Height of taller vase: 8.13 cm. (3¼ in.). Toledo (Ohio) Museum of Art

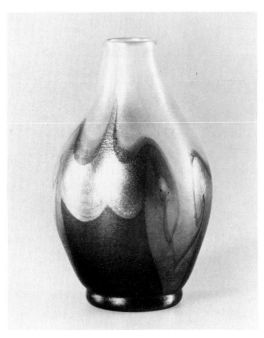

86

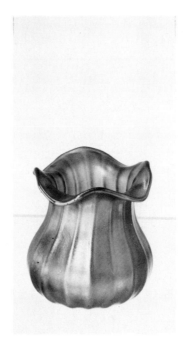

87

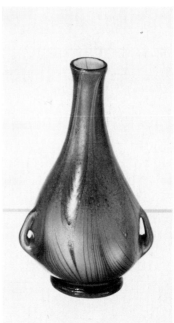

88

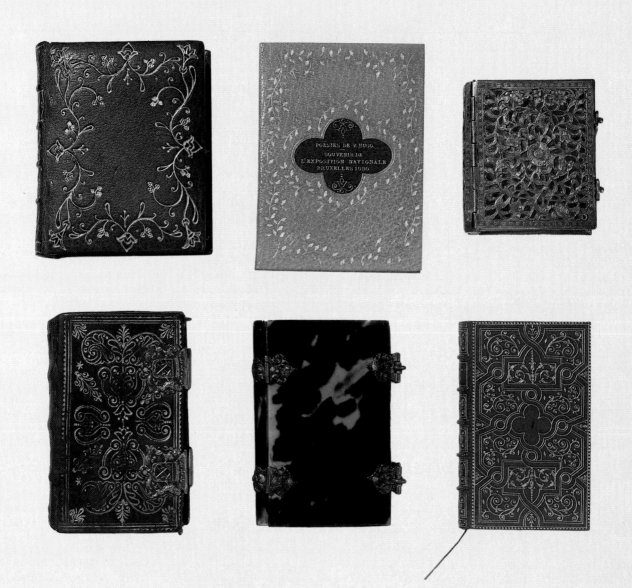

6 Miniature Books

Verisimilitude has been carried to an extreme in one of the most finicky of all miniature crafts: the printing and binding of miniature books. To produce a book of whatever size a number of aesthetic decisions have to be made in determining the choice of typeface, the size of type, the ratio of type area to page size, the quality of paper and the style of binding (colorplate 24). Some of the finer miniature books—those that are handmade rather than produced for a mass market—are printed on handmade paper and bound with great care. The really interesting miniature books are printed from hand-set type that has been cut by hand in a size so small that it would seem to defeat the human eye, although miraculously it is legible. Today this is virtually a lost art, since it is possible to reduce any page to any size photographically.

To make a miniature book, type, pages and binding all have to be incredibly reduced in scale—yet the book is manufactured just as its full-size counterpart would be (plate 89). The pages of special stock are hand-sewn together, bound with cardboard and trimmed to the right size, and then the binding, often of morocco leather, is put on. The finished product has, of course, some of the fascination of the Lord's Prayer on the head of a pin. But these are real books, meant to be read and entirely readable.

How small is miniature? One of the most authoritative catalogues of miniature books, the *Spielmann Catalogue* (London, 1961), declares three inches to be the maximum height. Most collectors agree, while many prefer to limit themselves to two and one-half inches. Experienced collectors usually are flexible about the maximum size in the case of exceedingly beautiful, unusual or rare works. The first printed books were larger than the average contemporary book; a page from

Colorplate 24.
A variety of miniature books and bindings produced over the last two hundred years. From left to right, top row: *The Little Robinson Crusoe*, bound in green leather with gold tooling. Philadelphia and New Haven: H. C. Peck and Theo. Bliss, and Durrie and Peck, n.d. Height: 7.5 cm. (3 in.); *Poésies de Victor Hugo*, with a modern American binding of crushed citron leather. Brussels: Groupe Ouvrier de L'Imprimerie A. Lefèvre, 1880. Height: 8.5 cm. (3⅜ in.); *Der Alten Testament Mittler*, with a pierced silver cover. Germany: n.p., n.d. Height: 5.3 cm. (2⅛ in.).

Bottom row: *Almanach*, bound in leather with gold tooling. Amsterdam: Johannes Stichter, 1693. Height: 7.8 cm. (3⅛ in.); *'t Nieuw Groot Hoorns*, bound in tortoise-shell with chased silver hinges and clasps. Tot Hoorn, 1690. Height: 7.5 cm. (3 in.); Horace's *Opera Omnia*, bound in red leather with gold tooling. Paris: Mesnier, 1828. Height: 7.5 cm. (3 in.). The Grolier Club of New York

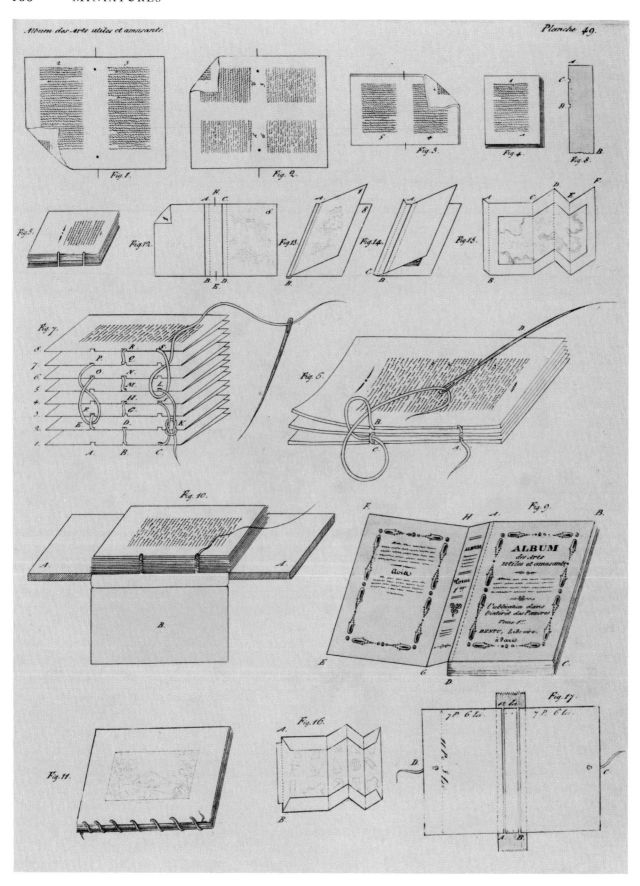

Fig. 1.

Fig. 2.

Fig. 3.

Fig. 4.

Fig. 8.

Fig. 5.

Fig. 12.

Fig. 13.

Fig. 14.

Fig. 15.

Fig. 7.

Fig. 6.

Fig. 10.

Fig. 9.

ALBUM
des Arts
utiles et amusants.

DENTU, Libraire,
à Paris.

Fig. 11.

Fig. 16.

Fig. 17.

89.
The processes are the same for making miniature and full-size books. Fig. 1 shows a printed page to be folded into a folio. Figs. 2–4 illustrate the making of a quarto. Figs. 5–7 indicate the ways in which the folios can be stitched together. Fig. 8 shows the notching of the folio necessary to allow the stitching to lie flat against the binding. Figs. 9 and 10 demonstrate the laying on of the cover. Fig. 11 shows a variant binding stitch. Figs. 12–17 illustrate scoring and bending techniques for making different kinds of covers. Reproduced from *Album des arts utiles et amusants*, Paris, 1832. Cooper-Hewitt Museum

the Gutenberg Bible, for instance, measures about 11 by 15 inches (28 by 38 centimeters). Many fifteenth-century attempts at miniaturization, considered phenomenally small at the time, are almost normal size by present-day standards. Yet for their rarity and exquisite craftsmanship no serious collector would want to exclude these from a collection. Whatever the size, a basic principle of miniature book collecting, as of collecting miniatures in general, is that good workmanship rather than diminutive dimensions alone is what counts.

The earliest books were handwritten on *scrolls*. By the fourth or fifth century A.D. these scrolls had been largely superseded by the *codex*, whose form was much like that of the modern book, consisting of folded leaves of parchment or vellum, both made from the skins of animals, bound together along one side. A codex was typically larger than the average book of today, although during the Middle Ages small handwritten Books of Hours were made for priests to carry around. Boccaccio describes seeing at the library of Monte Cassino large manuscript books whose margins had been cut off to supply parchment for these little volumes.

Early book sizes are described by the number of times the individual sheets of paper—originally 19 by 24 inches—used in them were folded. If the printer so arranged his type that there were two pages on each side of a sheet, the resulting book is called a *folio*. When the sheet was folded, it would form four numbered pages of the book. Arranging the type so that the individual sheets were to be folded twice after printing would produce a *quarto*: from one sheet, eight numbered pages would result. Another fold would result in an *octavo*, with sixteen numbered pages. Other arrangements of type might produce even more pages, with the individual page size becoming smaller each time.

The size of a miniature book often corresponds to the size that would result if a sheet were folded six times, thereby producing sixty-four pages per sheet, or a book two and one-half inches tall. The name for this format is *sexagesimo-quarto* (sixty-four), and for this reason a miniature book is sometimes called a "64-mo," after the printer's shorthand for the term. Because it was impractical to fold a piece of paper that many times, however, miniature books were usually made from half or quarter sheets, allowing for fewer—and more accurate—folds.

The production of a miniature book involves laborious tasks. From the invention of printing in Europe in about 1450 to the end of the century only a hundred or so editions of books were produced that might be considered miniatures. The Newberry Library in Chicago owns a fine example of one early miniature with manuscript decora-

tions: the *Alphabetum divini amoris*, attributed to the French theologian Jean de Gerson and others, and probably printed by Johann of Auerback at Basel sometime after 1491 (colorplate 25). Its printed pages are faintly ruled by hand in brown ink; although functionally useless, these lines were an imitation of those used in handwritten books to guide the scribes. At that time printed books were considered to be inferior to handwritten books. Decorations were therefore often added to give the printed book the feel of a manuscript. The pages of the *Alphabetum* are also *rubricated*: capital letters here and there were ornamented by hand in red ink after printing. Finally, the text contains a type character of a hand pointing with the forefinger, to stress a particularly significant passage.

The first codex books, produced at the beginning of the Christian era, tended to be bound with wooden boards covered with leather. Bindings became more delicate in the late Middle Ages, and by the sixteenth century, embroidery, inlays, and even original paintings appeared on the covers of books. Books could be bound in gold and silver and encrusted with gemstones and mother-of-pearl. Edges of books were *goffered*: goffering is the *fluting* or cutting of a design upon the paper edges of a book, which might then be *tooled* in gold or stained in other colors. And bindings in unusual shapes—circles, crosses, hearts or octagons (plate 90)—were also made. In the eighteenth century, books with *fore-edge paintings* appeared; the front edge of the leaves was painted in such a way that the scene was indecipherable when the book was open and would make sense only when the book was closed.

Colorplate 25.
The Alphabetum divini amoris, attributed to Jean de Gerson, is an early miniature book. Faint brown guidelines like those used by scribes were printed on its pages to give the book the appearance of a hand-copied manuscript. Rubrication, or the addition of red ink, increased this effect. Probably Basel, printed by Johann of Auerbach, after 1491. Height: 8.6 cm. (3 7/16 in.). The Newberry Library, Chicago

90.
A sermon given in 1640, on the two hundredth anniversary of printing, forms the text of this little octagonal volume entitled *Eine Christliche Danck-Predigh*. The Guild of Printers probably gave the book to its members in commemoration of the bicentennial of the art of book printing. German, 1678. Leather binding with metal clasp. Height: 6.3 cm. (2½ in.). Rare Book Division, New York Public Library, Astor, Lenox and Tilden Foundations. *Shown actual size.*

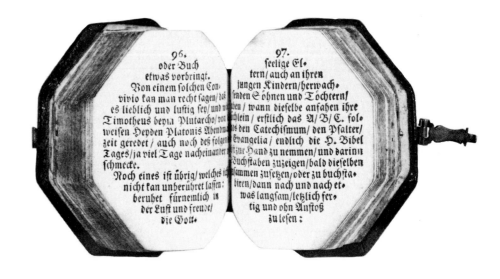

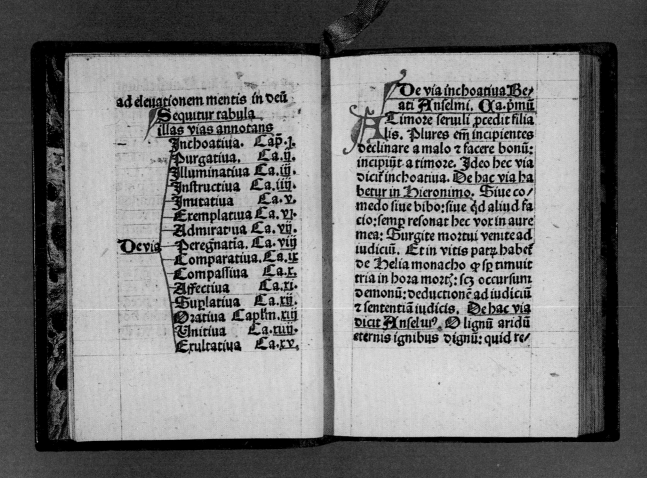

ad eleuationem mentis in deū
Sequitur tabula
illas vias annotans

Inchoatiua. Cap̄.j.
Purgatiua. Ca.ij.
Illuminatiua Ca.iij.
Instructiua Ca.iiij.
Imutatiua Ca.v.
Exemplatiua Ca.vj.
Admiratiua Ca.vij.
De vijs Peregrinatia. Ca.viij
Comparatiua. Ca.ix
Compassiua Ca.x.
Affectiua Ca.xi.
Suplatiua Ca.xij.
Oratiua Caplm.xiij
Unitiua Ca.xiiij.
Exultatiua Ca.xv.

De via inchoatiua Beati Anselmi. Ca.pmū

Timore seruili pcedit filialis. Plures eñ incipientes declinare a malo z facere bonū: incipiūt a timore. Ideo hec via diciť inchoatiua. De hac via habetur in Hieronimo. Siue comedo siue bibo: siue qd aliud facio: semp resonat hec vox in aure mea: Surgite mortui venite ad iudiciū. Et in vitis patz habet de Helia monacho qp sp timuit tria in hora mortz: scz occursum demonū: deductione ad iudiciū z sententiā iudicis. De hac via dicit Anselmus. O lignū aridū eternis ignibus dignū: quid re

Silversmiths made exquisite filigree cases for miniatures during the eighteenth century (plate 92). Some metal cases made for miniature books were adorned with a design appropriate to the content. Many late-nineteenth-century editions of the Book of Common Prayer had silver covers with the embossed faces of angels on the front, while some works of literature or poetry bore the embossed face of the author. Bindings might also have clasps or occasionally rings so that the book could be worn as a pendant on a necklace, a belt or a *chatelaine* (plate 91).

About two hundred titles of miniature books are known to have been printed during the sixteenth century. This number doubles again, to four hundred, in the seventeenth century, and in the eighteenth century, over six hundred and fifty miniature titles are known to have been issued (plate 93). The smallest book of the sixteenth century was a beautiful prayer book printed in Paris by Germain Hardonyn. Measuring about 24 by 32 millimeters (15/16 by 1¼ inches), it spanned a little over one square inch. In the seventeenth century, many books were printed with covers measuring less than that. The smallest volume of that century was the remarkable *Bloem-Hofje Door* (*Little Flower Garden*), a fifty-page book of moral verses by C. van Lange, printed in Holland in 1674 by Benedikt Schmidt as an exhibition of his technical ability. Type was not adequately small yet, and in order to squeeze his beautifully cut letters into a book measuring 8 by 12 millimeters (5/16 by ½ inch), or less than half the size of a small postage stamp, van Lange ran the text across both pages of a two-page spread. *Bloem-Hofje Door* remained the world's smallest book until the very end of the nineteenth century. Only four or five copies of this masterpiece of the printer's craft are known to exist: one of them brought $14,000 at a 1979 auction in London.

At the outset of printing, a major incentive to miniaturize was for practical reasons: long-distance travelers by coach desired "travel libraries" that economized on space. In the seventeenth century pockets began to appear in coats for the first time, and certain books were designed to be carried about in them. Thus, Napoleon was able to bring an entire library along with him on his campaigns.

Sometime after the invention of the printing press, the ability to miniaturize passed beyond what was needed for convenience; yet printers continued to shrink books as showpieces of typographical skill. Typefounders competed with each other to see who could exercise the most talent and ingenuity in cutting minuscule type, artists continued to reduce the size of their illustrations, printers created ever smaller pages, and binders bound the results into ever more minute dimensions. The smallest type to date was cut by the French

Colorplate 26.
Miniature personal calendars were often rendered precious by being given beautiful bindings. This copy of *Mein Catholicher Schreib-Calendar* has a chinoiserie-inspired lacquer cover inlaid with mother-of-pearl and silver and bound with tooled and gilded leather. German, Augsburg, 1766. Height: 8 cm. (3¼ in.). The Grolier Club of New York. *Shown larger than actual size.*

91.
Chased and worked in repoussé, this silver case was intended to hold a miniature book —perhaps, since a cupid adorns its cover, a book of verse from a special admirer. European, probably eighteenth century. Height: 4.4 cm. (1¾ in.). The Grolier Club of New York

92.
This miniature memorandum book dates from the late eighteenth century when such books were popular. The silver-gilt cover is pierced and engraved with figures of mounted hunters, whimsical architecture and decorative foliage. An opening in the center of the cover frames a miniature painted pastoral scene. Not visible in the photograph is a fine ivory pencil that is pushed through loops to fasten the book closed. French, eighteenth century. Height: 8.8 cm. (3½ in.). The Grolier Club of New York

91

92

93

94

95

96

typographer Didot when he was sixty-six years old. He used the type in what was to become his most famous miniature, his 1828 edition of Horace (see colorplate 24).

The nineteenth century may be called the "golden age" of miniature books (plates 94, 95 and 96). The making and collecting of tiny tomes became fashionable, and production soared: three thousand miniature editions appeared in that century alone. Empress Eugénie,

93.
Volumes by the classical authors were produced in miniature in great numbers. This floral-designed cover contains a volume in Latin of Cicero's dialogue on friendship, *M. T. Ciceronis De amicitia dialogus.* French, Paris: J. G. Graevii, 1749. Height: 5.6 cm. (2¼ in.). The Grolier Club of New York

94.
Nineteenth-century books were often sumptuously bound. This miniaturization of the eighteenth-century French book, *Ver-Vert* by Jean-Baptiste-Louis Gresset, has a tooled red leather binding that is further ornamented with green paint and gilding. The inside cover is decorated with a richly colored figure of an exotic parrot. Paris: Editions Mignardise, 1855. Height: 8.1 cm. (3¼ in.). The Grolier Club of New York

95.
Bound in fine red leather with gold embossing, this miniature volume, *Misanthropie et Repentir, ou les Epoux Réunis,* includes full-page hand-colored illustrations. French, Paris: Janet, 1801. Height: 9.7 cm. (3⅞ in.). The Grolier Club of New York

96.
Each of the four volumes of this set, *Les Quatre Elémens,* contains two engravings —one illustrating the benefit of the particular element (earth, air, fire or water), and the second the dangerous aspect. Bound in boards covered with embossed paper. French, Paris: Maulde & Renou, nineteenth century. Height: 8.1 cm. (3¼ in.). The Grolier Club of New York

All books on these two pages are shown actual size.

wife of Napoleon III, was reported to have a collection of several thousand miniature books, which would have made it the largest in the world. Her collection was lost during *la semaine sanglante* of May 1871, when French government troops crushed the insurgent Paris Commune, and the Tuileries Palace burned to the ground.

In 1896, a copy of a letter from Galileo was printed in Padua in the form of a miniature book, *Galileo a Madama Cristina de Lorena* (plate 97). In the letter, written in 1615, the famous Italian scientist tried to convince the Grand Duchess Christina of Sweden, mother of the reigning prince, of the truth of the heliocentric theory. This volume, which measures about 18 by 20 millimeters (11/16 by 13/16 inch), was bound in *vellum*, leather or paper, and bore the title *Galileo* and the name *Cristina* in gold lettering on the spine. It was one of the last miniature books to be printed from movable type, and one of the smallest of any considerable length (207 pages). It was made with two-point "fly's-eye" type, and included an original miniature portrait of Galileo opposite the title page. Setting the type was reportedly so laborious that some of the compositors suffered permanent severe eye damage from working on the volume.

To print from movable type, the printer must pick out of his typecase, one letter at a time, those pieces of type that will make up his text. He assembles letters and spaces into lines, and then these lines into pages. Groups of four, eight, sixteen, thirty-two or even sixty-four pages are locked together into a metal frame called a chase in such a position that, when printed and properly folded, the pages of the book will appear in the right order. The size of type in an ordinary book is usually between ten and twelve points. Twelve-point type (about the size of pica typewriter letters) averages twelve characters to the inch. Two-point type, so small that a magnifying glass is needed in some

97.
The *Galileo a Madama Cristina di Lorena* was for many years the smallest miniature book printed from movable type. This edition is bound in fine leather with gold tooling. The text was printed in the microscopic "fly's-eye" type (about two-point type). Italian, Padua: Salmin Brothers, 1896. Height: 1.8 cm. (¾ in.). Private collection

Colorplate 27 and Plate 98.
Photographic reproduction was used to re-
duce the type of this book, *The Smallest
English Dictionary in the World*, to the
equivalent of 1½-point type. Printed on thin
India paper, the book has 384 pages with
41 lines of type per page, and includes a
frontispiece of Dr. Johnson and a dedication
to "Mrs. Kendal in appreciation of kindly
encouragement to the production of tiny
articles, of which she has a great collection."
A magnifying glass is set into the silver case,
which has been conveniently provided with
a ring so that it can be worn as a pendant.
New York: David Bryce & Son, n.d. Height:
2.5 cm. (1 in.). Cooper-Hewitt Museum,
gift of Susan Dwight Bliss. *Plate 98 shown
actual size.*

instances to make sure that the right letters have been chosen from the case, has a mere thirty-six characters of type per inch of text.

Even using tweezers to handle the type, typefounders and printers had gone about as far as they could go with such books as the *Galileo*. It remained, in the late nineteenth century, to introduce photographic methods of reducing type size in order to produce the next stage in the miniaturization of books.

In 1900 a copy of Omar Khayyám's *Rubáiyát*, rendered into English verse by Edward FitzGerald, was made with the help of photographic reduction. A copy of the book was printed, photographed, and then reduced. All forty-eight pages of the reduced text were then engraved onto one copper printing plate, with three verses of the text on each page. Printed by Charles H. Meigs of Cleveland, Ohio, the book measured 9.4 millimeters (⅜ inch) square, was cloth-bound, and Mr. Meigs's personal copy was set into a silver ring with a catch fastening. Meigs's *Rubáiyát* remained the smallest book in the world from 1900 to 1932. Only fifty-seven copies were made. Two were presented to the Library of Congress (one was later returned to Meigs after he lost his), and a number of the rest were sold to subscribers at fifteen dollars apiece. Today, these elfin volumes fetch several hundred dollars each at auctions.

At the end of the last century, David Bryce, a Glasgow publisher, began producing *The Smallest English Dictionary in the World* (colorplate 27 and plate 98), "comprising besides the ordinary and newest words in the language, short explanations of a large number of scientific, literary and technical terms." By photographically reducing the text, he fitted all this into 384 pages, and then included a magnifying glass in the case so that the book could be used, and not remain just a curiosity. If this smacks of a tour de force, it was nevertheless a successful one. Bryce wrote: "I had many a scoff and jeer as to the absurdity of the production; nevertheless, it at once appealed to Mr. Pearson of the notable weekly, who gave me a first order for 3,000 copies and its sales are now over 100,000." In addition to this dictionary Bryce also published *The Smallest New Testament, The Smallest Bible, The Smallest Alphabet*, Gray's *Elegy* and a string of other titles. By the end of his career, he had printed more miniature books than had been printed in the entire history of miniature book production that preceded him.

Miniature books with religious content seem to have inspired particular care (plate 99). Miniature, or "thumb," Bibles, for instance, are often extremely beautiful, carefully decorated and ornately illustrated. Works of Jewish literature in miniature have received considerable attention. One 1885 edition of the Siddur, or prayer book

99

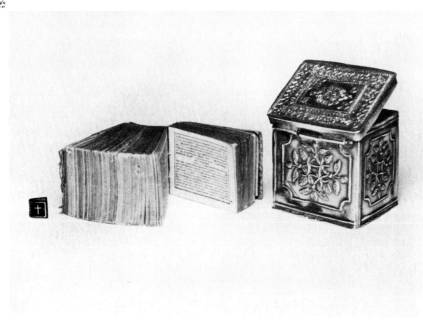

100

99.
Miniature calendars of saints' days were usually beautifully illustrated and bound. This set is illustrated with a saint for each day and is bound in four volumes, with three months in each volume. It is covered in vellum and stamped with gold decoration. French, 1800. Height: 1.9 cm. (¾ in.). Private collection

100.
This Indian religious book is printed on such fine paper that the tiny volume contains several thousand pages. It is covered in a soft silk, and a silver box was specially designed to protect it. Indian, nineteenth century. Height of book: 2.3 cm. (15/16 in.). Private collection

101.
Miniature almanacs were often carried about in people's pockets so that they could be referred to easily. The *Almanack for the Year of Christ 1792, The Almanack Explained* was printed for London's Company of Stationers; it was bound in red tooled and gilded leather, further decorated with blue and white paint. English, London, 1792. Height: 5.6 cm. (2¼ in.). The Grolier Club of New York

101

Colorplate 28.
These three miniature almanacs, *Verbesseretes Sack-Calenderlein*, have gaily painted covers showing figures in period and theatrical costume. The slipcases are of glazed paper. German, Nuremberg, 1727, 1750 and 1785. Height: 6.3 cm. (2½ in.). The Grolier Club of New York

for the entire year, was bound with olivewood from Jerusalem.

Calligraphy is a highly valued art in the Arab world, and one of its prized applications is in transcribing the Koran. Muslim women wear miniature Korans, and Muslim men carry them into battle. These so-called Banner Korans are typically octagonal, and fit inside a round velvet case which is in turn inserted into a silver or brass case hung with a chain over the top of the military standard. The pages of these Korans are very elaborately decorated, with colored inks and as many as three different shades of gold leaf.

The tradition of miniaturizing religious books in India is an ancient one, and so precious and fragile were these endeavors that it was usually necessary to design a special metal box in which to store them (plate 100). They were usually illustrated and decorated with gilt, and they were written in a number of Indian languages, including Sanskrit. A few miniature Sanskrit *Bhagavad Gitas* were produced in Glasgow about 1900 by the Scottish publisher David Bryce without any English imprint, causing one to wonder about their purpose and final destination.

Certain categories of books readily lend themselves to miniaturization. Personal calendars are made small so that they can be carried in a purse or pocket and consulted for important appointments (see colorplate 26). Almanacs, too, have been popular in small sizes, since they contain information that people find useful to have at their fingertips: the movements of the tides, the phases of the moon, a calendar of holidays, currency conversion tables, and the reigns of national monarchs and rulers (colorplate 28 and plate 101). The kind of information in almanacs changed little from year to year, although it was ephemeral, and people usually threw away last year's almanac to replace it with an up-to-date version at the start of the new year. The illustrations were different in each edition, and frequently a great deal of care went into their design and binding.

During the eighteenth, nineteenth and early twentieth centuries, these charming little books were published in all parts of Europe (plate 102), the finest probably in England, France and Italy. Many Italian almanacs, particularly those of the early nineteenth century, contain beautiful illustrations in color. The *London Almanacks*, as well as Dutch almanacs, are of special interest to present-day collectors because of the beauty of their bindings.

Miniature almanacs were also made in America, although they were not usually illustrated or finely bound until the late nineteenth or early twentieth century, when enormous numbers were produced as advertisements with leather bindings and colored illustrations. Because

of their beauty and quantity, many of these have been preserved.

At the beginning of the nineteenth century, children's books were made in miniature, and sometimes sold in specially made cabinets or boxed sets. One of the finest and rarest is *The Cabinet of Lilliput*, printed by John Harris of London in 1802. It consisted of a series of twelve miniature books, each measuring 70 by 68 millimeters (2 ¾ by 2 11/16 inches), housed in a wooden cabinet whose cover was decorated with angels. At about the same time John Marshall published his "infant's library," a sixteen-volume set, also with its own case, but with slightly smaller books, for younger children (plate 103).

Series of classical works have been popular in miniature, and the challenge of fitting the complete works of Shakespeare into tiny volumes has captured the imagination of a number of publishers (colorplate 29). Sets vary in size and can be found in twelve, twenty-four and forty volumes.

History has been a favorite topic for American miniature books (plate 104) and so have love and marriage (plate 105). One miniature title was actually banned in this country: *Fruits of Philosophy; or, the Private Companion of Young Married People*, written in 1832 "by a young physician," a book about birth control.

102.
Among the most desirable of miniature almanacs are the delightful volumes published by C. F. Müller in Karlsruhe in the nineteenth century. Special attention was given to the illustrations, many of them well designed and executed with great detail. German, Karlsruhe, 1837. Height: 1.9 cm. (¾ in.). Private collection

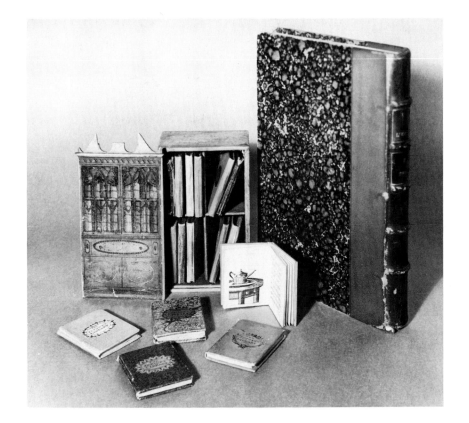

103.
The "infant's library" published by John Marshall in England is a favorite among collectors. The sixteen volumes, each on a different topic, are appealingly illustrated with pictures of alphabets, flowers, boys' and girls' games, and other subjects of interest to children. The books are bound in boards of pastel shades and fit into a case with four compartments lined with pink paper. English, London, 1800. Height of open book: 5.6 cm. (2¼ in.). Museum of the City of New York

104

105

104.
Three American presidents, Abraham Lincoln, George Washington and Calvin Coolidge, are honored in these miniature volumes. The book on Lincoln is bound in red leather and features speeches of Abraham Lincoln; that on Washington is bound in brown leather and contains his farewell address; and that on Calvin Coolidge is bound in blue and includes extracts from his autobiography. American, Kingsport, Tennessee: Kingsport Press, 1932. Height: 2.2 cm. (⅞ in.). Private collection

105.
"Take heed of yoking yourselves with untamed heifers," warns the preacher William Secker in this miniature volume bearing his sermon on marriage, *A Wedding Ring Fit for the Finger*. American, Boston: N. Buttolph, 1705. Height: 8.5 cm. (3¼ in.). Rare Book Division, The New York Public Library, Astor, Lenox and Tilden Foundations

Colorplate 29.
Dedicated by special permission to Miss Ellen Terry (1848–1928), the famous Shakespearean actress, this miniature set of Shakespeare's plays is beautifully printed on laid paper and bound in blue cloth with plastic on-laid stiffeners to give the appearance of vellum. The paper label on the spine has been carefully textured to look like leather. The text was scrupulously edited and compared with the best texts of Shakespeare for accuracy and even includes a glossary. Glasgow: David Bryce & Son, n.d. Height: 5.3 cm. (2⅛ in.). The Folger Shakespeare Library, Washington, D.C.

Currently, over sixty presses in the United States are producing miniature books, most of them printing several titles yearly. Hungary, Japan and Yugoslavia are even more active. In Hungary alone there are reported to be at least ten thousand collectors of miniature books, and some new titles are published in editions of up to eight thousand copies. Interest in miniature books is growing worldwide amongst collectors and printers. Today, there are a number of books under 1.6 millimeters (1/16 inch) square from several different countries. The smallest book in the world is only a curiosity, however, and of less interest than the many beautiful, slightly larger miniatures that have been bestowed with exquisite craftsmanship over the past four hundred years. Fortunately, these still continue to be produced on many different topics.

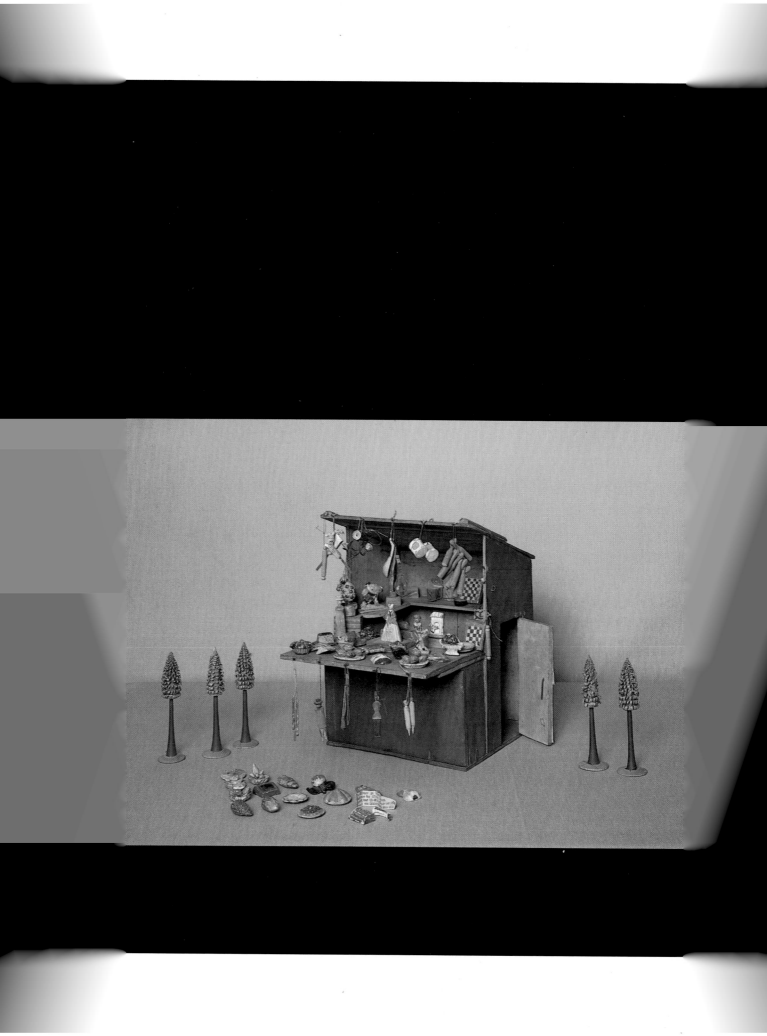

7 Advice for Collectors

"Never attend auction rooms; in the first place because they are not the place for a lady; and in the second, because, unless endowed with extraordinarily acute perception, you are almost certain to be woefully imposed upon."

This dire piece of advice was written by Isabella Mary Beeton (1836–1865) in her remarkable *Book of Household Management* (1861). While today we even have plenty of women auctioneers, there is still a certain truth in Mrs. Beeton's warning, especially as it pertains to the collector of miniatures.

Now that dollhouses and miniatures of all varieties have come into such vogue, they are increasingly appearing at very healthy prices at auction. The first thing that any collector interested in an auction lot should do—if he or she can arrange it—is to look over the lot and *all* its pieces very carefully. Many are the regrets of the collectors of full-size antiques who opened three but not four drawers of a chest to find that one had been irreparably damaged, or, perhaps worse, replaced. This kind of careful examination can be exceedingly difficult where miniatures are involved, since whole housefuls of furniture are apt to be wrapped up in a plastic bag and one must often make do with peering through the plastic. Of course, there are some pleasures in playing the game of mystery grab bag. Among a lot of undistinguished chairs and tables, you may find one really nice antique piece.

As with auctions of all antiques, it pays to learn as much about your subject as you can. Subscribe to the journals and magazines that publish news of other collectors and that advertise shows and sales. Unlike collectors in many major fields, who are well known to the

Colorplate 30.
Butcher shops, grocery stores, pharmacies, even milliners' shops can all be found in miniature. An array of tiny toys and foods are offered for sale in this shop. Several of the figures are made of a flour and sugar mixture and contain slips of paper with maxims written on them, a discovery that was made when one of the figures was accidentally broken. Zurich, Switzerland, c. 1800. Height of shop: 27.5 cm. (11 in.). Washington Dolls' House and Toy Museum, Washington, D.C.

public, collectors of miniature antiques are known primarily to their colleagues.

A group of miniature book enthusiasts became active in America in the 1920s, and in 1927 founded a periodical dedicated to miniature books and the problems of collecting them. Called the *Newsletter of the LXIVmos* (the 64-mos), it ran through twenty-one issues, to October–November 1929. These issues are still a valuable reference source. Since then there have been three other American periodicals for the miniature book collector, one of which is still being published.

A problem that the miniature collector is apt to run into at auction is that as the desirability, and hence the price, of miniature antiques goes up, valuable sets are likely to be sold by the piece. This has happened with more than one fine dollhouse. Again, it is crucial to know as much as possible about the specific object or objects you wish to buy. Request information on the history of the ownership of the piece, which may be valuable for your own files. Make sure that the lot of furniture you bid on is indeed the lot that came from the house you have just bought. The same cautions apply whether one is buying from a dealer, an auction house or another collector.

Today, because of the rising value of miniature antiques, it is difficult to find a bargain when buying through dealers rather than at auction. The dealer's price for an original early-nineteenth-century dollhouse with any or all of its original furnishings intact may put it beyond the reach of all but museums and rich collectors. However, in the case of individual pieces of furniture, and other miniature items such as porcelain tea sets and miniature books, specialized dealers can clearly be the right people to turn to.

There is no substitute for experience, and while the mistake of spending good money for some object that turns out to be inferior is seldom forgotten, it is both cheaper and more pleasant to become educated by visiting museum collections and reputable dealers. One must see pieces again and again in order to gain an appreciation for such factors as the patinas of wood, the delicacy of hand carving and painting, the correct proportions of a genuine *Adam-style* chair. Examine the details carefully for things you would look for in the full-size article. Is a chest of drawers *doweled* or glued? Is a plate transparent and delicate, or is it heavy and ill-balanced? Have there been major replacements of structural parts or hidden repairs?

The problem of reproductions is a difficult one in the field of miniatures. Usually reproductions are at least partially made by machine and thus can never have the quiet hand-and-eye-corrected proportions of the truly old and handmade ones. There is a common saying that if you put one reproduction into a roomful of originals,

it will give itself away. This is especially true of pre-nineteenth-century miniature decor and furnishings, since these were almost invariably made by the same people who made the full-size pieces and knew a great deal about how real chairs, teapots, and so forth, were actually made, as opposed to most miniaturists today, whose interest is usually confined to the techniques of making tiny objects.

Barring accidents or malice, hardly anything can destroy a well-made miniature except time. And even time, as Meket-Re's miniature rooms testify, has to be rather patient. Children's play, of course, may involve a high degree of wear and tear, but miniatures are not collected as children's toys so much as products of art and skill made by grownups to be looked at and admired.

If you are lucky or diligent (or both) and you happen to discover a lovely old dollhouse or suite of furniture, there are a few guidelines to follow. First, whenever original paint or paper exists, preserve it. Even if the outside paint of a house has peeled away until nothing more than a pale wash of its original hue remains, resist the urge to give it a bright new coat. Sometimes the transition between regarding a miniature object, such as a dollhouse, as an antique rather than a toy is a hard one. But if a piece is indeed an actual antique, it should be treated with all the respect one would give the full-scale piece.

Fill any dangerous-looking structural cracks in the wood with wood compound; but if the holes are innocuous, leave them alone. Pests can be a problem in houses or furnishings, constructed, as they are, of such inviting materials as wood, glue, paper and cloth. If you suspect that a piece has furniture beetles, isolate it and have it treated.

Beetles are also fond of books and paper, as are those little bugs called silverfish. These objects should be fumigated, and it may be best to turn to an expert restorer for help. Restorers should also be consulted in the case of mildew, which can ravage dollhouses and furnishings made of cardboard as well as books and prints.

Metal pieces present specific problems. Copper and brass, silver and lead, are all supposedly easy to clean, but it is also easy to damage their patina. Jewelers use various foams and powders to clean and polish these metals gently; it is best to look for these trade products. Bronze has very special problems and should be tended by an expert. Pewter's delicate old luster can also be easily destroyed by cleaning, so ask a specialist for advice.

Glass should be kept well ventilated. If it is kept wrapped up, or stored in a humid place, it may turn cloudy. Always make sure to clean each piece of antique glass separately, since one piece of glass can scratch another.

Because they are so small, miniatures are difficult to display. They

can be easily upset on an unprotected surface by a child running hard a few steps away, a cat's leap or a sudden gust of wind. Keeping fragile miniatures behind or under glass is a good idea, especially since the glass can act to mitigate certain changes of heat and moisture in the air.

Miniature books will not relentlessly claim all free level space the way ordinary books may, but collecting them again poses its own difficulties—the problem may even be that they take up too little space. Several recent miniature books are less than 1.6 millimeters (1/16 inch) square, about the size of a matchhead, and anything that tiny is easily misplaced. One of the best ways of storing them is in the hard plastic containers used by numismatists to display coins; these are transparent from all sides and are easily labeled and filed. If you select the right size, the book will be fixed securely in place and will not bounce around. Caution should be exercised, however, since the long-term effects of enclosing books in plastic are unknown. To be safe, the books should be removed from plastic storage boxes periodically to be inspected for damage and to be aired. The collector who decides to use plastic boxes should keep in touch with a paper conservator who will inform the collector of any new developments in the research on the effects of plastic on paper and leather. Bookshelves for the larger miniatures can be made from clock cases or doll wardrobes. While most miniature books can be read with the naked eye, some require a magnifying glass of more than ten-diameter power to read. A magnifying glass mounted on four legs enables one to hold the book underneath it and turn the pages with both hands.

Because they are easy to lose and to mislay, miniatures should be insured. Throughout history thieves have been just as fond of valuable miniatures as of their full-size counterparts. Your collection can be covered under most home or apartment owners' policies, so inquire of your insurance agent what the estimated cost of such additional coverage will be. The collection should be photographed and catalogued for your own records as well as the insurance company's. Start a card file listing the general description, size, date of acquisition, price and any other information that would help you identify the piece if it was lost. And remember to revalue the collection periodically.

A last word about taste and value. Every amateur collector is advised to buy only things that he or she really loves, and to buy the best things that he or she can afford. Most professionals follow this dictum as well. It is never wise to buy for investment something that you wouldn't be pleased to live with if its value did not in fact increase.

But buying for love is not just homey advice for making peace with eccentricities of taste versus vagaries in the marketplace. If you love a field, you will learn about it, and as your learning develops you are very apt to uncover new areas of antiques that are not yet collected, or are undervalued. Miniatures comprise nearly every category under the sun. Almost everything that exists has no doubt at one time or another been made in miniature. Dollhouse Duncan Phyfe furniture may be all the rage at the moment, but tomorrow something else will take its place, only to be replaced in its turn. The best advice is to go where your heart leads you—whether to fancy auctions or rummage sales in rural church basements. If you follow your heart, what you find is always bound to please you.

Glossary

Adam style, in the style of the eighteenth-century British architect and designer, Robert Adam (1728–1792), whose elegant furniture was ornamented with Neoclassical designs.

baby house, a house reproduced in small scale, not necessarily as a toy for children; this early term preceded the use of the term "dollhouse" in England.

balustrade, a row of small posts that support a railing.

Biedermeier, a simple style of light-colored wood furniture favored in Germany and Austria about 1820–40. Ornamentation was limited and often done in contrasting woods.

blue-and-white, a term commonly applied to pottery and porcelain with painting in cobalt blue under the glaze.

chased, decorated with an indented surface design created by using a punch.

chatelaine, a decorative chain worn by women and fastened with a clasp or pins.

Chinese export porcelain, porcelain made in China expressly for export, particularly during the eighteenth century.

chinoiserie, a Western style of decoration that imitates Chinese designs.

Chippendale, a style of furniture named after the English designer Thomas Chippendale (1718?–1779). The style is characterized by curvaceous lines and naturalistic decorations such as floral designs, shells and claw-and-ball feet.

Coalbrookdale, a Shropshire, England, porcelain factory founded in 1780, also called Coalport. Miniature porcelain tableware was produced there, particularly during the nineteenth century.

codex, a manuscript in the form of a book.

dollhouse, a small-scale house, not necessarily a toy for children or meant to be inhabited by dolls. The term was first used in England in the eighteenth and nineteenth centuries.

doweled, fastened with a wooden pin or peg, as in the joining of two pieces of wood.

Duncan Phyfe, a style named for the prolific American cabinetmaker (1768–1854), who produced furniture in the Empire style.

Dutch cabinet, a cabinet used for storage and display of objects, including miniature rooms and furniture.

Empire, the late Neoclassical French style of furniture (1799–1815), which combined antique forms with Neoclassical elements; characterized by use of opulent drapery.

en suite, contained in a series or a set.

favrile, the name generally applied to Louis Comfort Tiffany's iridescent glass. The iridescent effect was achieved by exposing molten glass to the fumes of vaporous metals.

Federal style, a chronological period which dates from the establishment of the United States Federal government in 1799 to about 1830. The style was delicate and utilized very slim proportions, dark woods and beautiful inlays of contrasting colored woods.

filigreed, decorated with twisted or beaded wire that is shaped into a pattern.

fluting, a decoration consisting of shallow parallel grooves on a vertical surface.

folio, two leaves of a book or codex created by folding one piece of paper in half.

fore-edge painting, a painted scene on the front edges of a book which is only clearly visible when the book is closed.

gilding, decoration of applied gold.

goffering, the fluting or cutting of a design upon the paper edges of a book, which might then be tooled in gold or stained in other colors.

hallmarks, marks struck into a silver object to identify the quality of the metal, the date and the place of the marking.

jasperware, a hard, translucent stoneware produced by Wedgwood beginning in 1775. The clay itself is white but can be stained by mixing the color with raw clay as it is made or by applying it to the surface of the formed piece.

maiolica, the generic term for tin-glazed earthenware made in Italy.

octavo, an eight-leaf section of a book or codex created by folding one piece of paper in half three times.

poppenhuizen, a Dutch term meaning "dollhouse."

porcelain, a brittle, white, translucent ceramic made by firing pure clay and glazing it with various colors. Hard-paste porcelain is fired at very high temperatures; soft-paste porcelain, which is made by mixing pure clay with a glassy compound called frit, is fired at lower temperatures.

porseleinkamer, the Dutch term for the room in which porcelain was displayed. These rooms were very popular in seventeenth-century Holland.

quarto, a four-leaf section of a book created by folding one piece of paper in half twice.

raising, a method of forming vessels by hammering a disc of metal against cast-iron rods of various sizes until the desired shape is realized.

repoussé, a method of decorating metal by pushing the surface out from behind with special metal tools and dies.

rococo, a very light and elegant style of the eighteenth century which originated in France and is characterized by the use of S-curves, naturalistic motifs and chinoiserie.

rubricated, colored red. When referring to manuscripts it means the red coloring of the initial letters.

scaling down, reducing in size according to a fixed ratio.

scroll, a manuscript or book in the form of a roll of paper or parchment.

sexagesimo-quarto ("64-mo"), a 64-page section of a book or codex created by folding a single sheet of paper in half six times.

Sheraton style, a type of elegant eighteenth-century English furniture with simple outlines and elaborate painted or inlaid decoration, named for its designer, Thomas Sheraton (1751–1806).

slat-backed settee, a settee made with a flat piece of wood for the back support.

tin-glazed earthenware, pottery glazed with a mixture of tin and lead compounds that produces an opaque white surface when fired.

tooling, decoration made by impressing a surface with special tools.

transfer-printed decoration, a process in which a design from a specially inked copper engraving is transferred by way of a thin paper transfer to the surface of a glazed piece of pottery.

trompe l'oeil, a French term meaning, literally, to fool the eye—usually applied to painting in which the perspective is so calculated that the scene or object looks real.

vellum, fine-grained, unsplit lamb- or calfskin used in book binding and furniture making.

verre de soie, a type of glass developed by Frederick Carder at Steuben Glass. The surface of a translucent glass was sprayed, while still nearly molten, with stannous chloride to give it an iridescent, silky surface.

Windsor chair, a chair with shaped wooden seat and doweled back, first used outdoors in England in the seventeenth century.

Reading and Reference

ADOMEIT, RUTH. *Three Centuries of Thumb Bibles: A Checklist.* New York: Garland, 1980.

BENSON, A. C., AND WEAVER, SIR LAWRENCE. *The Book of the Queen Mary's Doll's House.* 2 vols. London: Methuen, 1924.

BONDY, LOUIS W. *Miniature Books.* London: Sheppard Press, 1981.

The Collection of Miniature Books formed by Arthur A. Houghton, Jr. Auction catalogue. New York: Christie, Manson & Woods, Ltd., 1979.

Colleen Moore's Fairy Castle. Chicago: The Museum of Science and Industry, 1964.

GREENE, VIVIEN. *English Dolls' Houses of the Eighteenth and Nineteenth Centuries.* New York: Charles Scribner's Sons, 1975.

———. *Family Dolls' Houses.* London: G. Bell & Sons Ltd., 1973.

HOUART, VICTOR. *Miniature Silver Toys.* Translated by David Smith. New York: Alpine Fine Arts Collection, Ltd., 1981.

JACOBS, FLORA GILL. *A History of Doll Houses.* New York: Charles Scribner's Sons, 1st edition, 1953; 2nd edition, 1965.

———. *A World of Doll Houses.* New York: Gramercy Publishing Co., 1965.

———. *Dolls' Houses in America.* New York: Charles Scribner's Sons, 1974.

———. *Victorian Dolls' Houses and Their Furnishings.* Washington, D.C.: The Washington Dolls' House and Toy Museum, 1978.

LECHLER, DORIS, AND VIRGINIA O'NEILL. *A Collector's Guide to Children's Glass Dishes.* Nashville, Tenn.: Thomas Nelson, 1976.

McCLINTON, KATHARINE MORRISON. *Antiques in Miniature.* New York: Charles Scribner's Sons, 1970.

MILBOURN, MAURICE AND EVELYN. *Understanding Miniature British Pottery and Porcelain: 1730–Present Day.* Woodbridge, Suffolk: The Antique Collectors Clubs, 1983.

NOBLE, JOHN. *A Fabulous Dollhouse of the Twenties.* New York: Dover Publications, 1976.

O'BRIEN, MARIAN MAEVE. *The Collector's Guide to Dollhouses and Dollhouse Miniatures.* New York: Hawthorn Books, 1974.

PINNEY, JANET. *The Stettheimer Dolls' House Presented to the Museum of the City of New York.* New York: The Museum of the City of New York, 1947.

SCHIFFER, HERBERT F. AND PETER B. *Miniature Antique Furniture.* Wynnewood, Pennsylvania: Livingston Publishing Co., 1972.

A Short List of Microscopic Books in the Library of the Grolier Club. New York: The Grolier Club, 1911.

SPIELMANN, PERCY E. *Catalogue of the Library of Miniature Books Collected by Percy E. Spielmann.* London: Edward Arnold, 1961.

THORNE, MRS. JAMES WARD. *American Rooms in Miniature.* Chicago: The Art Institute of Chicago, 1980.

———. *European Rooms in Miniature.* Chicago: The Art Institute of Chicago, 1980.

VON WILCKENS, LEONIE. *Mansions in Miniature.* Translated by Bell and Hyman, Ltd. New York: Viking Press, 1980.

Some Public Collections
of Miniatures

UNITED STATES

Boston:	Museum of Fine Arts
Chicago:	The Art Institute of Chicago
	Museum of Science and Industry
Corning, N.Y.:	The Corning Museum of Glass
Dallas:	Dallas Public Library
Dearborn, Mich.:	Greenfield Village and Henry Ford Museum
Hartford, Conn.:	Wadsworth Atheneum
New Haven, Conn.:	Yale University Art Gallery
New York City:	Cooper-Hewitt Museum,
	the Smithsonian Institution's National Museum of Design
	The Grolier Club of New York
	The Metropolitan Museum of Art
	The Museum of the City of New York
	The New-York Historical Society
	The New York Public Library
Norfolk, Va.:	Chrysler Museum of Art
Philadelphia:	Philadelphia Museum of Art
Phoenix:	The Phoenix Art Museum
Rochester, N.Y.:	The Margaret Woodbury Strong Museum
Salem, Mass.:	Essex Institute
Toledo, Ohio:	Toledo Museum of Art
Washington, D.C.:	Smithsonian Institution
	National Museum of American History, Division of Domestic Life
	The Washington Dolls' House and Toy Museum
Williamsburg, Va.:	Colonial Williamsburg
Winterthur, Del.:	Henry Francis du Pont Winterthur Museum

OTHER

Amsterdam:	Rijksmuseum
The Hague:	Gemeentemuseum
London:	Bethnal Green Museum of Childhood
	Victoria and Albert Museum
Manchester:	City of Manchester Art Galleries, Wythenshawe Hall
Nuremberg:	Germanisches Nationalmuseum
Paris:	Musée des Arts Décoratifs
Stockholm:	Nordiska Museet
Utrecht:	Centraalmuseum
Windsor, England:	Windsor Castle (Queen Mary's Dollhouse)
Zurich:	The Weber Collection

Index

Numbers in *italics* indicate pages on which black-and-white illustrations appear. Numbers in **boldface** indicate pages on which colorplates appear.

A
Albrecht V, Duke, 14
almanacs, 98, *110*, **111**, 112, *113*
Amstel, Sara Ploos van: House, *18*, *19*, 62; furnishings, *20*, *21*, 45, *46*, 82, **83**, 93
Amsterdam: silver, *66*, 67, *68*
Andrews, William, 72
Anne, Queen, 26
 furniture style, 55
Archipenko, Alexander, 13
Archipenko, Mme Gela, 13
Art Institute of Chicago: Thorne Rooms, frontis., 39, 41, **42**, 43, 47, 60, 62, 63
Augsburg: calendar, 105
 houses and rooms, 19, 70
 toys, 70
Austria: porcelain, 87, 88

B
baby houses: Dutch, 20–21, *22*, *23*, 62
 English, 26
 German, 13–14, **15**, *16*, 17, 17–18, 81
Band, Percy, 30
baroque furniture, 45, *46*, *48*
Bavaria: glass, 93
 houses and rooms, 13–14, **15**, *16*, 17, 17–19
Beale, George, 74
beetles and bugs, treatment for, 119
Beeton, Isabella Mary: *Book of Household Management*, 117
Belgium: books, 98
Bench, John, 93
Bennington pottery, 89, 91
Bentley, Albert, *61*
Bible, 98, 101, 109
Biennais, Martin, 50
Birmingham (England): glass, 94
 silver, 77, *78*
Bliss, Theo., 98
Boccaccio, 101
books, miniature, 99, 101–02, 104
 almanacs, 98, *110*, **111**, 112, *113*
 American, 98, 108, 109, *109*, 112, 113, 114, *114*
 Belgian, 98
 bindings, 98, 99, *100*, 102, *102*, 105, **105**, *106*, *107*, *110*, 112, *113*, *114*, **115**
 calendars, 105, *110*, 112
 care and treatment, 119, 120
 cases/covers, 98, 104, *105*, 108, 109, *110*, 112
 for children, 113, *113*
 classics, 98, 104, 106, *106*, 113, **115**

books, miniature (*continued*)
 codex, 101, 102
 collections, 99, 101, 106–07, 113, 114, 118, 119, 120
 display, 120
 Dutch, 98, 104, *105*, 112
 English, 33, 35, 109, *110*, 112, 113, **115**
 French, 98, 104, *106*, 106–07, *110*, 112
 German, 98, *102*, 105, **111**, 112, *113*
 Hungarian, 114
 Indian, *110*, 112
 Italian, 107, *107*, 112
 Japanese, 114
 movable type, 104, 107, 109
 paintings and illustrations, 104, *105*, *106*, 107, 109, *110*, **111**, 112, *113*
 photographic reduction, 108, 109
 process of book-making, 99, *100*
 religious, 98, 101, *102*, 104, 109, *110*, 112
 size, 99, 101, 104, 105–06, 109
 Swiss, **103**
 worn as ornament or protection, 104, *105*, 108, 109, 112
 Yugoslavian, 114
Boston & Sandwich Glass Company, 92, 94–95
Bouché, Louis, 13
Boullier, Antoine, 72
Bow porcelain, 86
Bradley, Jonathan, 72
brass, *16*, 112, 119
Brett, Rev. Dr. Philip Milledoler (and Brett House), 29
Bristol (England): glass, 92, *93*, 94
bronze, 119
Bryce & Son, David, 108, 109, 112, **115**

C
calendars, 105, *110*, 112
Canada: houses, *30*
Cane's End (near Reading, England): furniture, 50
Carder, Frederick, 97
Caughley porcelain, 86, *87*
Century of Progress (Chicago: 1933–34), 39
Charles II, King, 45, 46
Charlotte, Queen, 84–85
 Wedgwood Queen's Ware named for, 84–85
charms, *endpapers*, 11, *121*
Chelsea porcelain, 86
Chester: silver, 64, *65*, 77
children: books for, 113, *113*
 furniture for, 47, 51, 56
 pottery and glass for, 81
 see also toys
Chinese/Chinese export porcelain, 82, 84, 85, 89; *see also* Oriental pottery and porcelain

Chippendale, Thomas, 26, 49–50
Chippendale style, 10, 26, 50, 55, 55, *59*
Christina, Grand Duchess, 107, *107*
Cicero: *De amicitia dialogus*, 106
Clayton, David, *74*, 75
Clifton, John, 75
Coalport/Coalbrookdale porcelain, 86, 87
Colbert, Jean-Baptiste, 70
Cole, John, 72
collecting and collectors, 9, 11, 21, 117–21, 124
 books, 99, 101, 106–07, 113, 114, 118, 119, 120
 care and treatment, 119–20
 display, 120
 documentation, 118
 furniture, 45, 47, 50, 58, 60, 62, 118, 119
 glass, 81, 97, 119–20
 houses, rooms, and furnishings, 30, 32, 38–39, 41, 60, 119
 insurance, 120
 pottery and porcelain, 81, 82, 84, 85, 89
 reproductions, 118–19
 silver, 70, 71, 75, 77, 78, 119
collections, miniature, *46*, 55
Coney, John, 77, 78
Coolidge, Calvin, *114*
copper, *16*, 119
Corning Museum of Glass, 97
Court, Petronella de la: Baby House, 20–21, *22*, *23*, 62
Courtauld, Augustin, 75
Couturier, Pierre, 71
Crolius family, 87
Currier, Nathaniel, *30*, *53*
Currier & Ives, 30

D
Darwin family, 84
Daum, Antonin, 96
Daum, Auguste, 96
Dauphin (son of Louis XIV), 70–71
Delaherche, Auguste, 90
Delft pottery, 82
Derby porcelain, 86–87
Dickens, Charles: "Old Curiosity Shop," replica, 38, *40*
Didot, 98, 104, 106
dollhouses. *See* houses and rooms
dolls and figures: for houses and rooms, **12**, *22*, *23*, 23, 38
 as religious and ritual objects, 7–8, *8*, *9*
Doyle & Company, 94
Duchamp, Marcel, **12**
Durand, Victor (and Durand Art Glass), 97
Durrie and Peck, 98
Dutch cabinets. *See* houses and rooms, Dutch cabinets/cabinets

E

Edwards, John, 78
Edwards, Samuel, 78
Egypt (ancient): glass, 91
 burial models, *8, 8–9, 9*
Empire style: furniture, 55, *60, 62, 63*
 porcelain, *89*
England: books, 33, 35, 109, *110,* 112, 113,
 115
 furniture, 10, 26, *32,* 33, 35, 36, 45, 46, *48,*
 49, 50, 57, *61*
 glass, *92, 93,* 93–94
 houses and rooms, 26, *27,* 32, *32,* 33, *34,*
 35–36
 pottery and porcelain, 6, 80, 82, 84–87, *85,*
 86, 87
 silver, *64,* 72, *73,* 74, 74–75, *75, 76, 77, 78*
Eugénie, Empress, 106–07

F

fabrics and materials: houses, rooms, and
 furniture, *15,* 26, 27, 39, 50, 56–57, 60,
 60, 61, 62
 simulated by paint, **15,** 17
Federal style furniture, 55, 59
Fickler, Johann Baptiste, 14
Flaxman, John, 85
Fleming, William, 72
France: books, 98, 104, 106, 106–07, *110,* 112
 furniture, *40,* 46–47, 50
 glass, 93, 94, 95–96
 houses and rooms, 38–39, *40*
 pottery and porcelain, 87, 90
 silver, 71–72, *72,* 73
furniture, full-size, 47, 48–49, 55, 56, 57–58
 for children, 47, 51, 56
furniture, miniature, 45, 47–49
 American, 36, 38, 39, 41, **42,** 43, 47–49, *49,*
 51, 52, 52, 53, *53,* 55–58, *55–61,* 60, 62,
 63
 care and treatment, 119
 collections, 45, 47, 50, 58, 60, 62, 118, 119
 craftsmanship, 45, 46, 47, 49, 50, *52,* 55, 58,
 60, 62; apprentices, 47, 48, 49
 dating and documentation, 44, 45, 47, *48,*
 49, 50, 58
 Dutch, 19–20, *20,* 21, 22, 23, 24–25, *40,* 45,
 46
 Egyptian (ancient), 8
 English, 10, 26, *32,* 33, 35, 36, 45, 46, *48,* 49,
 50, 57, *61*
 faithful replicas, 10–11, 45, 47, 55, 62
 French, *40,* 46–47, 50
 German, *16, 17,* 17–18, *18–19,* 20
 Italian, 44, *48,* 54, 55
 mass production, 57–58, 60
 painting on, *16,* 49, *51, 52, 52, 52, 53,* 53
 patent models, 58
 as salesmen's samples, 47, 48, 49
 scale, 10–11, 47, 59
 silver, *67,* 70
 sizes of small furniture, 47
 as toys, 45, 47

G

Galileo a Madama Cristina de Lorena, 107,
 107, 109
Gallé, Emile, 95, 96
gardens, 8, 29, 35, 36
Geffen, Arnoldus van, *67,* 70

G

Germany: books, 98, *102,* **105, 111,** 112,
 113
 furniture, *16, 17, 17–18, 18–19,* 20
 glass, *91,* 93
 houses and rooms, 13–14, **15,** *16, 17,* 17–20
 pottery and porcelain, *16, 17,* 81–82, 87
 silver, *69,* 70, 70–71
 toys, *69*
Gerson, Jean de: *Alphabetum divini amoris,*
 102, *103*
glass, 81
 American, 92, *94,* 94–95, *95,* 96–97, *97*
 antiquity, 81, *91, 91,* 94, 96
 care and treatment, 119–20
 for children, 81
 collections, 81, 97, 119–20
 Dutch, 91
 English, *92, 93,* 93–94
 "favrile," 96–97
 French, 93, 94, 95–96
 German, *91,* 93
 Italian, *91, 96*
 pressed glass, 94, *94, 95*
 sizes, 81
Gleizes, Albert, 13
Goodwin, James, 72
Graevii, J. G., *106*
Great Exhibition of 1851 (London), 77
Greece (ancient): glass, 91
Greene, Vivien, 10, 30
Gresset, Jean-Baptiste-Louis, *106*

H

Hammond, Matthias, frontis.
Hammond-Harwood House: dining room,
 Thorne model, **frontis.,** 41, 62
Hardonyn, Germain, 104
Harris, John, 113
Henry VIII, King, 39, 46
Henshaw, Miss, 26
Hermitage (Andrew Jackson home):
 Thorne model of room, 41
Hitchcock, Lambert, 49
Holbein, Hans: portrait copied, 39, **42**
Holland: books, 98, 104, *105,* 112
 furniture, 19–20, *20,* 21, 22, 23, 24–25, *40,*
 45, *46*
 glass, 91
 houses and rooms, *18, 19,* 19–21, *22, 23,*
 24–25, 26, 82
 pottery and porcelain, 19, *22, 23,* 24–25, 82,
 83
 silver, 19, 20, *20,* 22, 23, *66, 67, 67, 68,* 70,
 72, *105*
Homans dollhouse, 26, 29
Horace: *Opera Omnia,* 98, 104, 106
houses and rooms: American, **frontis.,** *12,*
 26, 28, 29, 29–30, *31,* 36, 37, *38,* 38–39, *40,*
 42, 43, 60
 Canadian, *30*
 care and treatment, 119
 collections, 30, *32,* 38–39, 41, 60, 119
 craftsmanship, 14, 17, 26, 29, *32,* 38
 dimension and depth simulated by paint,
 17
 "dream houses" and fantasy, 30, *31,* 35–36,
 37, 38
 Dutch, *18, 19,* 19–21, *22, 23,* 24–25, 26, 82
 Dutch cabinets/cabinets (and furnishings),
 17–23, 19–21, 26, 45, *46,* 62, *67,* 70, 82,
 83, 93



houses and rooms *(continued)*
 as educational tool, 14, 23
 English, 26, 27, 32, *32,* 33, *34,* 35–36
 faithful replicas, 13, 14, 17–18, 26, 29, 30,
 32, 35, 39, 41, *62;* of exteriors, 26, 27, *28,*
 29; see also period rooms *below*
 French, 38–39, *40*
 gardens, 8, 29, 35, 36
 German, 13–14, **15,** *16, 17,* 17–20
 kitchens (and furnishings), *16, 17,* 18–19,
 20, 24–25, 81–82
 literature, art, and myth; as inspiration, 30,
 30, 34, 35–36, 37, 38–39, *40,* 50
 period rooms (and furnishings), **frontis.,**
 39, 41, **42, 43,** 47, 50, 60, 62, *63;* as movie
 backgrounds, 62
 scale, 10–11, 62
 shops and stores, *8, 8–9, 9,* 116
 as toys, 23, 26, 29, *34,* 35, 36
 wall treatments: fabric, 26, 27; painting,
 16, 17, 20, *23;* paper, 29
Hugo, Jean-Victor, 41
Hungary: books, 114

I

India: books, *110,* 112
insects, treatment for, 119
International Exhibition (Paris: 1878), 95
Italy: books, 107, *107,* 112
 furniture, 44, *48,* 54, 55
 glass, *91, 96*

J

Jacobs, Flora Gill, 30
Janet, *106*
Japan: books, 114
 pottery and porcelain, 82, 90
 see also Oriental pottery and porcelain
Jekyll, Gertrude, 35
Jewish literature, 109, 112
Johann of Auerbach, 101–02, **103**
Jones, Edward, 72

K

King, Muson, 94
King, Son & Company (Cascade Glass
 Company), 94, *95*
Kingsport Press, *114*
kitchens. *See* houses and rooms, kitchens
Köferlin, Anna, 13–14, 62
Koran, *112*
Kupjack, Eugene, 60, 62

L

Lachaise, Gaston, **12**
Lamerie, Paul de, 75, *75*
Lange, C. van: *Bloem-Hofje Door,* 104
Laurencin, Marie, 41
lead, 119
Leeds ware, 84
Lee Mansion, Jeremiah: drawing room,
 Thorne copy, 41, **43**
Leeuwarden: silver, 67
Lefèvre, Groupe Ouvrier de L'Imprimerie
 A., 98
Le Sage, John, 75
Levasseur, Etienne, 50
Limoges, 87

Lincoln, Abraham, *114*
literature: houses and rooms inspired by, 30, *30*, 35, *37*, 38–39, *40*, 50
see also books, miniature
Liverpool porcelain, 86
Lock, Nathaniel, 74
Louis XIV, King, 70, 71
furniture style, 50
Lowestoft porcelain, 85, 86
Lutyens, Sir Edwin, 35
Queen Mary's Dollhouse, 32, 33

M
McIlhenny, Parker, 97
Madden, Matthew, 74
Maier, August, 14
Malyn, Isaac, 74
Manjoy, George, 74
Margas, Jacob, 74
Marinoff, Fania (Mrs. Carl Van Vechten), 12
Marshall, John, 113, *113*
Mary, Queen, 35, 36
Dollhouse, 32, *32*, 33, 35
Mary, Queen of Scots, 39, 42
Matthew, William, 74
Maulde & Renou, *106*
Meigh and Sons, C., 85–86
Meigs, Charles H., 109
Meissen, 87, *89*
Meket-Re, 8, *8*, *9*
Mesnier, 98
Mignardise, Editions, *106*
mildew, treatment for, 119
Minton porcelain, 86
Molenaer, Jan Miense, 36
Monroe, William, 59
Monte Cassino library, 101
Monticello (Thomas Jefferson home):
Thorne model of room, 41
Moore, Colleen: Fairy Castle, 36, **37**, 38
motion pictures: "matting" process using miniature period sets, 62
Moucheron, Frederick de, *23*
Moulton, Ebenezer, 78
Mount Vernon: decorative motif on miniature porcelain, 82
Thorne model of rooms, 39, 41
Müller, C. F., *113*
music scores, 35

N
Nailsea Glass Works, 94
Napoleon Bonaparte, 104; *see also* Empire style
Nauroy, Etienne, 50
Netherlands. *See* Holland
Nostell Priory: Dollhouse, 26, 27; furniture, 10, 26, 49, 50
furniture, 49–50
Nuremberg: almanacs, 111
dollhouses and utensils, 13–14, **15**, *16*, *17*, 17–18, *18–19*, 70, 81
Nuremberg Baby House (Stromer House), 14, **15**, 17–18
kitchen and utensils, *16*, *17*, 81
Nuremberg kitchens, 19
Nymphenburg porcelain, 86

O
Oliver, Peter, 78
Omar Khayyám: *Rubáiyát*, 109

Oortman, Petronella: Baby House, 21, 62; kitchens, *24–25*
Oriental pottery and porcelain, 82, 83, 84, 85, *86*, 91; *see also* Chinese/Chinese export porcelain; Japanese, pottery and porcelain
Ozenfant, Amédée, 41

P
Paine, James, 26, *27*
painting, decorative: on book covers, *110*
dimension and depth simulated, 17
on furniture, *16*, *49*, 51, 52, *52*, **52**, *53*, **53**
on pottery and porcelain, 81, 84, 85, 87
to resemble fabric, **15**, 17
to resemble stone, 26, *27*
on walls, *16*, 17, 20, *23*
paintings, prints, and sculpture: book covers, illustrations, and leaf edges, 102, *104*, *105*, *106*, *107*, 109, *110*, 111, *112*, *113*
in houses and rooms, 12, 20, *22*, 23, *33*, *34*, 35, 36, *40*, 41, *42*, *43*, **63**
Palmer, Fanny, *30*
Peck, H. C., 98
Pelletreau, Elias, 78
Perdou de Subligny, 70–71
pewter, *16*, 119
Phyfe, Duncan, 55, 56
furniture style, 50, 55–56
Pickering, Matthew, 74
Popov factory, 87, *89*
poppenhuizen. See houses and rooms, Dutch; houses and rooms, Dutch cabinets/cabinets
pottery and porcelain, full-size, 82, 86
pottery and porcelain, miniature, 81
American, 82, 84, 87, 89, 91
Austrian, 88
for children, 81
collections, 81, 82, 84, 85, 89
craftsmanship, 85
Dutch, 19, *22*, 23, *24–25*, 82, 83
English, 6, 80, 82, 84–87, *85*, *86*, *87*
French, 87, 90
German, *16*, 17, 81–82, 87
markings, 7, *87*
Oriental, 82, 83, 84, 85, *86*, 91; Chinese/Chinese export, 82, 84, 85, *89*; Japanese, 82, 90
Russian, 87, *89*
Scandinavian, 87
sizes, 81
as toys, 84
transfer printing of patterns, 84, *86*

Q
Queen Anne style furniture, 55
Queen's Ware (Wedgwood), 84
Quezal Art Class and Decorating Company, 97, *97*

R
religious and ritual objects: books, 98, 101, *102*, 104, 109, *110*, 112
dolls and burial models, 7–9, *8*, *9*
Revere, Paul, I, 77, 78
Rockingham porcelain, 86
Roth, Leonard, *31*
Royal Crown Derby, 87
Rubinstein, Helena, 38–39, *40*, 50
Russia: porcelain, 87, *89*

S
Saint-Louis glass factory, 94
Salmin Brothers, *107*
Salmon, Dr. Ira Allen, *61*
Saunders and Shepherd, 64, *65*
Scandinavian porcelain, 87
Schiffer, Herbert, 47–48
Schiffer, Mrs. Margaret B., 49
Schmidt, Benedikt, 104
Secker, William, *114*
Shakespeare, William, 113, **115**
Sharp, Ann, 26
Sheffield silver, 77
Shenandoah pottery, 87, 89
Sheraton, Thomas, 56
furniture style, 50, **51**, 56
shops and stores, 8, *8*, *9*, 116
Shore, Emily, 91, 93
silver, full-size, 65
silver, miniature, 65–67, *71*, 79
American, 77, 77–78, 79
book covers/cases, 98, 104, *105*, 108, 109, *110*, 112
care and treatment, 119
collections, 70, 71, 75, 77, 78, 119
craftsmanship, 65, 70, 77; apprentices, 66, 67
dating and documentation, 71
Dutch, 19, 20, *20*, 22, *23*, 66, 67, *67*, 68, 70, 72, *105*
English, 64, 72, 73, 74, 74–75, *75*, 76, 77, *78*
French, 71–72, *72*, 73
German, *69*, 70, 70–71
lost wax method, 65–66
markings, 64, 66, *66*, 68, 70, 70–79, 72, 74, 75, 77–78
as salesmen's samples, 66, 67
sand casting, 66
toys, 67, *69*, 70, 72, *72*, 74, 79
Simmons, William, 75
Smith, Harry, 29
Smith, Joseph, 72, 74
Sneek (Holland): silver, 67, *68*
Spode porcelain, 85, 87
Sprinchorn, Carl, 13
Staffordshire pottery and porcelain, 6, 80, 85–86, *86*
Stettheimer, Carrie: house, 12, 38, *38*
Stettheimer, Etta, 13
Stettheimer, Florine, 13
Steuben Glass Works, 97
Stichter, Johannes, 98
Stockbauer, J., 14
Stone, Arthur, 79
Storrs, John, 41
Stromer House. *See* Nuremberg Baby House
Survage, Léopold, 41
Swansea porcelain, 86
Switzerland: books, 103
shops, 116

T
techniques: books, 99, *100*, 104, 107, 108, 109
collecting and reproductions, 118–19
craftsmanship, 11, 101; books, 99, 101, 104, 107, 109, 114; furniture, 45–50 *passim*, 52, 55, 58, 60, 62; houses and rooms, 14, 17, 26, 29, 32, 38; pottery and porcelain, 85; silver, 65, 66, 67, 70, 77
dimension and depth in houses and rooms, 17

techniques (*continued*)
 faithful replicas: furniture, 10–11, 45, 47, 55, 62, **63**; houses and rooms, **frontis.**, 13, 14, 17–18, 26, 27, *28*, 29, 30, 32, 35, 39, 41, **42**, **43**, 47, 50, 60, 62; ritual figures and models, 8
 mass production, 11, 57–58, 60, 94
 same skills as full size, 11, 45, 47, 65–66, 81, 99, *100*, 119
 and scale, 10–11, 47, 59, 62
Terry, Ellen, 114
Thomson, Virgil, **12**
Thorne, Mrs. James Ward (and Thorne Rooms), **frontis.**, 39, 41, **42**, **43**, 47, 60, 62, **63**
Tiffany, Louis Comfort, 96–97, *97*
toys: furniture, 45, 47
 glass, 93, 94
 houses and rooms, 23, 26, 29, *34*, 35, 36
 pottery and porcelain, 84
 silver, 67, *69*, 70, 72, *72*, 74, 79
Treeling, Franciscus, *68*
Tudor style furniture, 39, **42**, 45–46

U
Uffenbach, Zacharias Konrad von, 21
Ulm: kitchens, 19
United States: books, 98, 108, 109, *109*, 112, 113, 114, *114*
 furniture, 36, 38, 39, 41, **42**, **43**, 47–49, *49*, 51, 52, *52*, **52**, **53**, *53*, 55–58, *55–61*, 60, 62, **63**
 glass, **92**, *94*, 94–95, *95*, 96–97, *97*
 houses and rooms, **frontis.**, **12**, 26, *28*, 29, 29–30, *31*, 36, 37, *38*, 38–39, **40**, **42**, **43**, 60
 pottery and porcelain, 82, 84, 87, 89, 91
 silver, 77, 77–78, 79

V
Vauban, Sebastian le Presle de, 70
Venetian glass, 91, 93, *96*
Victoria, Queen, 87
Victorian style: furniture, 50, 58, 60, *61*
 pottery and porcelain, 85
 silver, 77
Vineland Glass Works, 97

W
Washington, George, *114; see also* Mount Vernon
Wedgwood, Josiah, 84
Wedgwood pottery, 84–85, *85*
Westbrook, Elizabeth, 26
Whieldon/Whieldon-type pottery, 6
Wilkinson, Sir Nevile: Titania's Palace, *34*, 35–36
William and Mary style, 46, *48*
Wilson, Claggett, 13
Winn, Lady, 26, *27*, 62
Wolfsohn, Helene, *89*
Wolrad, Johann Jacob, 70
Worcester porcelain, 86, *87*
Wren, Sir Christopher, 41

Y
Yugoslavia: books, 114

Z
Zorach, Marguerite, 13

Acknowledgments

For their expert advice and assistance, the Cooper-Hewitt Museum wishes to thank M. L. Grisante Associates, Ann Adelman, Laurie Platt Winfrey and Dorothy Sinha; Ruth E. Adomeit of Cleveland; Flora Gill Jacobs of the Washington Dolls' House and Toy Museum; Mr. Herbert F. Schiffer of Philadelphia, and Dr. and Mrs. Stanley H. Greenwald of New York.

Cooper-Hewitt staff members have been responsible for the following contributions to the series: concept, Lisa Taylor; administration, Christian Rohlfing and David McFadden; coordination, Sheryl Conkelton and Rosemary Corroon. In addition, valuable help has been provided by S. Dillon Ripley, Joseph Bonsignore, Susan Hamilton and Robert W. Mason of the Smithsonian Institution, as well as by Gloria Norris, Edward E. Fitzgerald, Madeleine Karter, Neal T. Jones and the late Warren Lynch of Book-of-the-Month Club, Inc.

Credits

Ruth Adomeit, Cleveland, Ohio: plates 97, 99, 100, 102, 104. The Art Institute of Chicago: color *frontispiece*, 6, 7, 8, 9, 16. Bethnal Green Museum of Childhood, London: plates 26, 47. Black Creek Pioneer Village, Toronto: plate 18. Centraalmuseum, Utrecht: plates 10, 11 and 48. Chrysler Museum, Norfolk, Va.: plate 86. Cooper-Hewitt Museum: color 10, 17, 20, 22, 27; plates 27, 50, 51, 69, 70, 79, 89, 98; *endpapers* (all, Scott Hyde). The Corning Museum of Glass, Corning N.Y.: color 23; plates 80, 81, 82, 83, 84, 85. The Folger Shakespeare Library: color 29. Folger's Silver Collection, The Procter & Gamble Company: plate 65. Gemeentemuseum, The Hague: color 19; plates 6, 7, 8, 9, 25. Dr. and Mrs. Stanley Greenwald, New York: plates 72, 76, 77 (all, Scott Hyde). The Grolier Club of New York: color 24, 26, 28; plates 91, 92, 93, 94, 95, 96, 101. Greenfield Village and Henry Ford Museum, Dearborn, Mich.: plates 32 through 39. Flora Gill Jacobs, The Washington Dolls' House and Toy Museum, Washington, D.C.: color 30; plates 3, 11, 15, 16, 20, 21, 23, 24. The Metropolitan Museum of Art: plates 1, 2, 52 through 56, 60. Museum of the City of New York: color 2; plates 17, 22, 103. Museum of Fine Arts, Boston: color 15, 18, 21; plates 64, 67, 68, 71. Museum of Science and Industry, Chicago: color 5. The New-York Historical Society: color 1 (Scott Hyde). The Newberry Library, Chicago: color 25. Office du Livre, Fribourg, Switzerland: plate 49 (Victoria and Albert Museum, London, Crown Copyright), and plate 59. New York Public Library, Rare Book Division, Astor, Lenox and Tilden Foundations: plates 90 and 105. Rijksmuseum, Amsterdam: plate 12. Lord St. Oswald, M.C., Nostell Priory: plates 13 and 14. The Smithsonian Institution (Division of Domestic Life): color 12 through 14; plates 19, 29, 30. The Toledo Museum of Art, Toledo, Ohio: plates 78, 87, 88. Verlag Georg D. W. Callwey/Helga Schmidt-Glassner: color 3; plates 4 and 5. Windsor Castle, Windsor, England, Copyright Reserved: color 4. The Henry Francis du Pont Winterthur Museum, Winterthur, Del.: color 11; plates 28, 31, 42, 43, 44, 46, 57, 58, 61, 62, 63, 66, 73, 74, 75. Yale University Art Collection, New Haven, Conn.: plates 40, 41, 45.

Grateful acknowledgment is made for permission to quote from the following sources: *A History of Dolls' Houses*, Flora Gill Jacobs, Charles Scribner's Sons, New York, 1965; *Miniature Silver Toys*, Victor Houart, Office du Livre, Fribourg, Switzerland, 1981; *Mansions in Miniature*, Leonie von Wilckens, Verlag Georg D. W. Callwey, Munich, 1980.